FUN WITH CLAY

BY TOMOKO KANAI

CONTENTS

(Make sure you read this before starting)

Cover: See p. 43

ONDORI

★ Copyright © 1984 ONDORISHA PUBLISHERS, LTD. All rights reserved.
★ Published by ONDORISHA PUBLISHERS, LTD., 11-11 Nishigoken-cho, Shinjuku-ku, Tokyo 162, Japan
★ Sole Overseas Distributor: Japan Publications Trading Co.,Ltd.
 P.O.Box 5030 Tokyo International, Tokyo, Japan
★ Distributed in the United States by Kodansha America, Inc.
 through Farrar, Straus & Giroux,19 Union Square West, New York, NY 10003
 in British Isles & European Continent by Premier Book Marketing Ltd.,1 Gower Street, London WC1E 6HA
 in Australia by Bookwise International,54 Crittenden Road, Findon, South Australia 5023, Australia

10 9 8 7 6 5 4
ISBN 0-87040-605-1
Printed in Japan

♥THE NEIGHBORHOOD GIRLS♥

Wall Ornaments

Sally

Meg

These wall ornaments are completely flat in back. Place the pattern on a rolled-out piece of clay, cut out the outline and then start putting the face and arms on top, using the method explained on p.78.

Nancy

Katie

• See p.2 for details on how to make these.

Sweet little girls in checked shirts.
First read the basic methods on p.74. Then draw the lines, insuring the paint is completely dry each time. The order is vertical, horizontal and lastly, where they cross.

What to Use

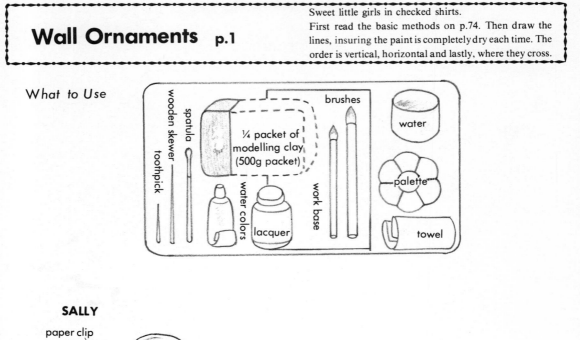

wooden skewer
spatula
toothpick
¼ packet of modelling clay (500g packet)
brushes
water
palette
water colors
lacquer
work base
towel

SALLY

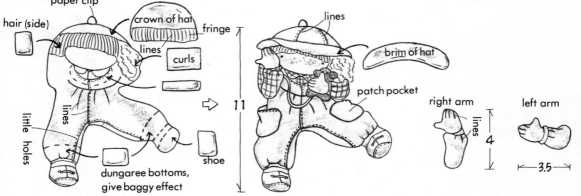

paper clip
hair (side)
crown of hat
fringe
lines
curls
lines
little holes
dungaree bottoms, give baggy effect
shoe
11
lines
brim of hat
patch pocket
right arm
lines
4
left arm
3.5

MEG

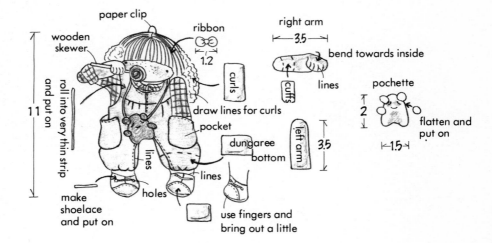

paper clip
ribbon
right arm
3.5
wooden skewer
roll into very thin strip and put on
11
1.2
curls
bend towards inside
cuffs
lines
pochette
2
draw lines for curls
pocket
left arm
3.5
flatten and put on
1.5
make shoelace and put on
lines
holes
lines
dungaree bottom
use fingers and bring out a little

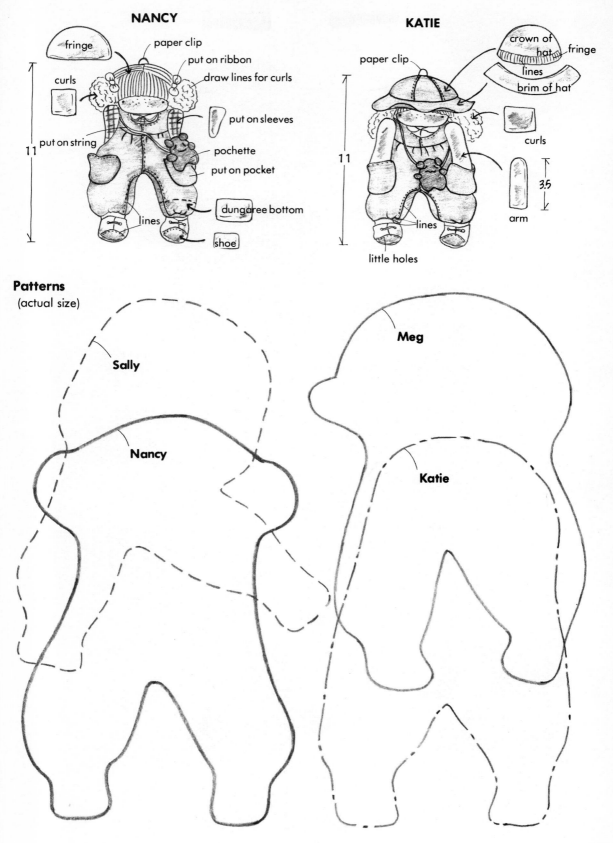

NANCY

fringe

curls

11

put on string

paper clip

put on ribbon

draw lines for curls

put on sleeves

pochette

put on pocket

dungaree bottom

lines

shoe

KATIE

paper clip

crown of hat

fringe

lines

brim of hat

curls

11

arm

3.5

lines

little holes

Patterns
(actual size)

Sally

Nancy

Meg

Katie

3

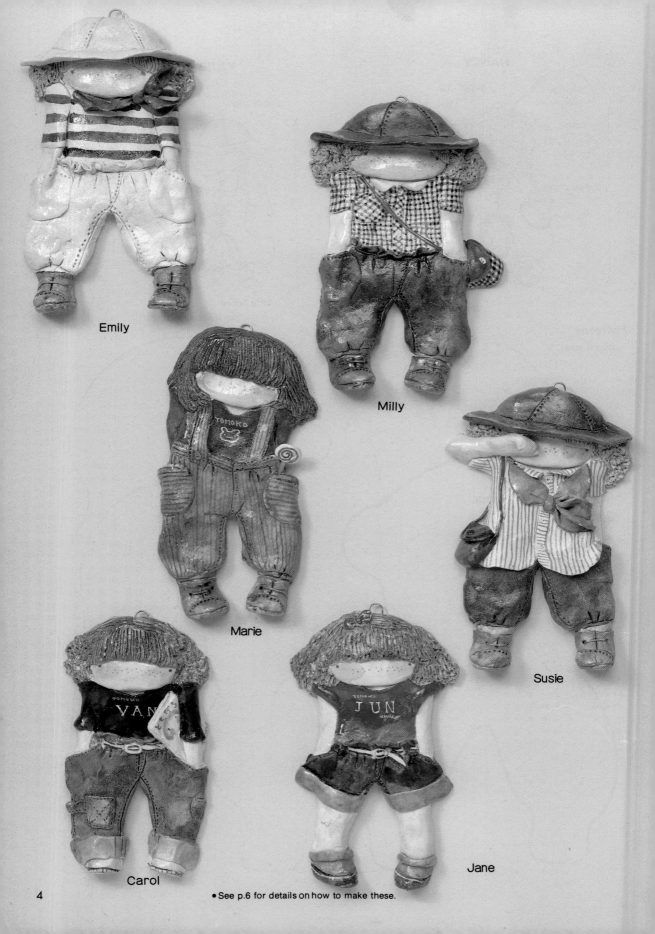

Emily

Milly

Marie

Susie

Carol

Jane

4 • See p.6 for details on how to make these.

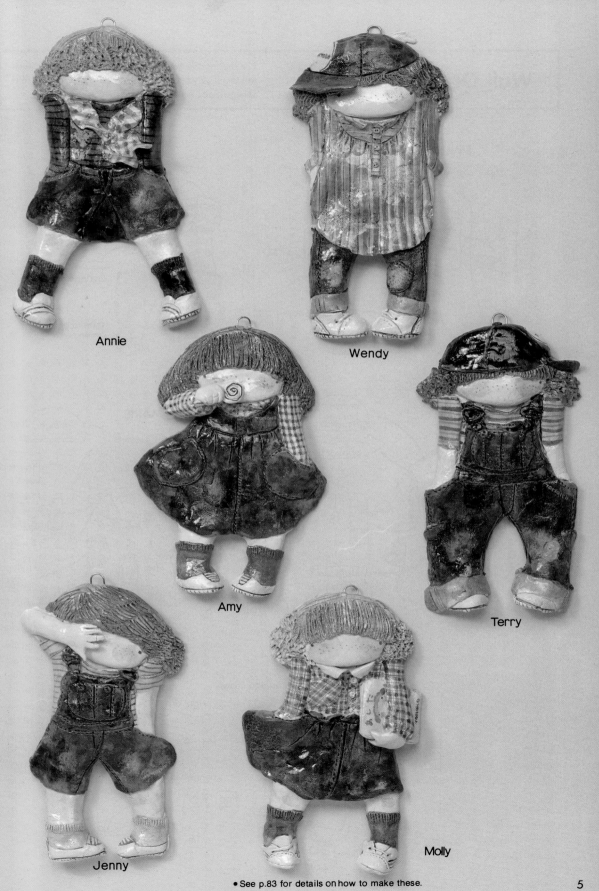

Annie

Wendy

Amy

Terry

Jenny

Molly

• See p.83 for details on how to make these.

Wall Ornaments p.4

For the "harlem pants" waist, stick on a piece of thinly rolled-out clay and arrange gathers so that it looks like an elasticized waistband.

EMILY

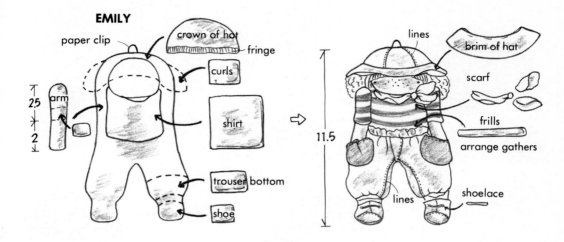

paper clip

crown of hat — fringe

curls

shirt

arm

2.5

2

trouser bottom

shoe

lines

brim of hat

scarf

frills

arrange gathers

11.5

lines

shoelace

MILLY

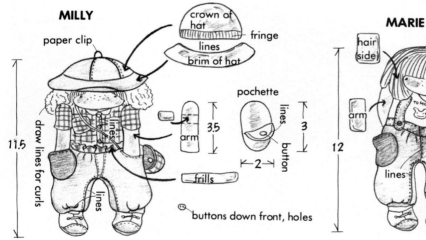

paper clip

crown of hat — fringe

lines

brim of hat

draw lines for curls

11.5

lines

lines

lines

arm

3.5

pochette

lines

button

3

2

frills

buttons down front, holes

MARIE

fringe

hair side

hair (side)

braces

arm

arm

button

2.5

0.7

neckline

lines

12

lollypop

2

put in pocket

SUSIE

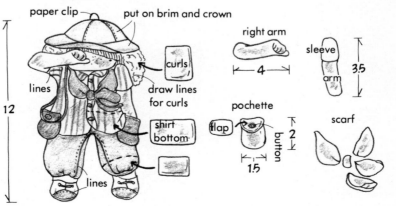

paper clip

put on brim and crown

lines

curls

draw lines for curls

shirt bottom

12

lines

right arm

4

sleeve

arm

3.5

pochette

flap

button

2

1.5

scarf

6

CAROL

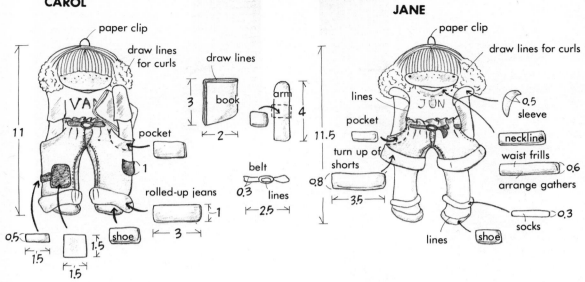

paper clip

draw lines for curls

book — draw lines

3

2

arm

4

11

VA

pocket

1

rolled-up jeans

11.5

belt

0.3 lines

2.5

0.5

1.5

1.5

1.5

shoe

1

3

JANE

paper clip

draw lines for curls

lines

0.5 sleeve

JON

pocket

neckline

turn up of shorts

waist frills

0.6 arrange gathers

0.8

3.5

socks 0.3

lines

shoe

Patterns (actual size)

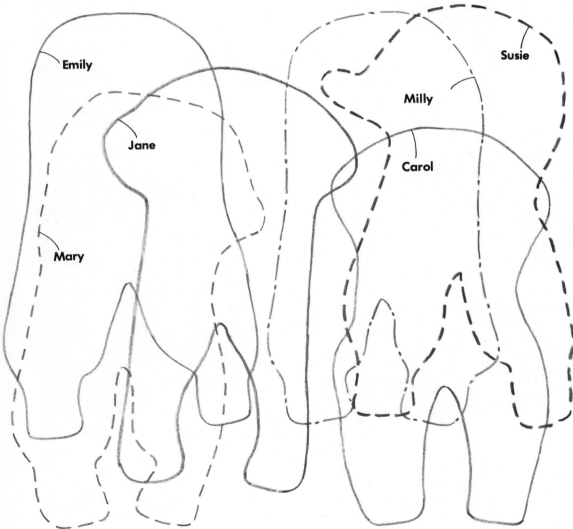

Emily

Susie

Milly

Jane

Carol

Mary

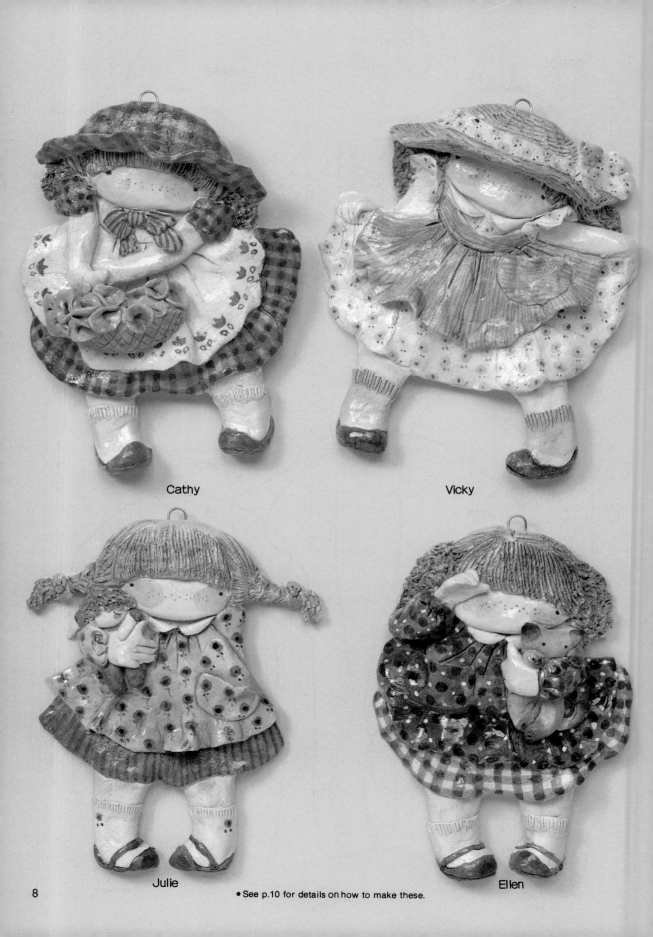

Cathy

Vicky

Julie

Ellen

• See p.10 for details on how to make these.

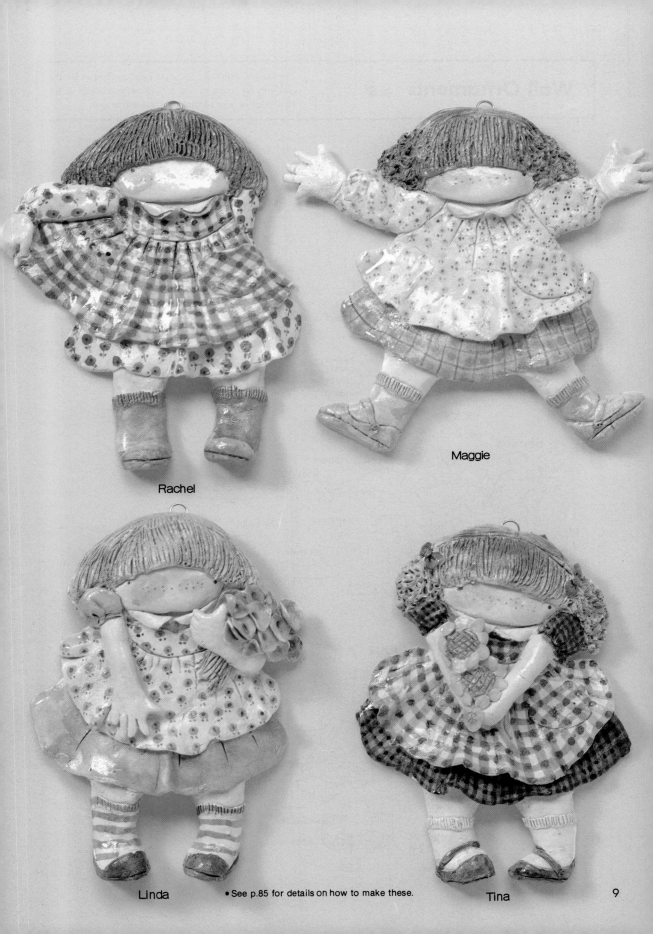

Rachel

Maggie

Linda

• See p.85 for details on how to make these.

Tina

9

Wall Ornaments p.8

For the girl with braids, use the same method as for the girl with the frying pan on p.78. Reinforce braids with a thin piece of wire so that they will not break.

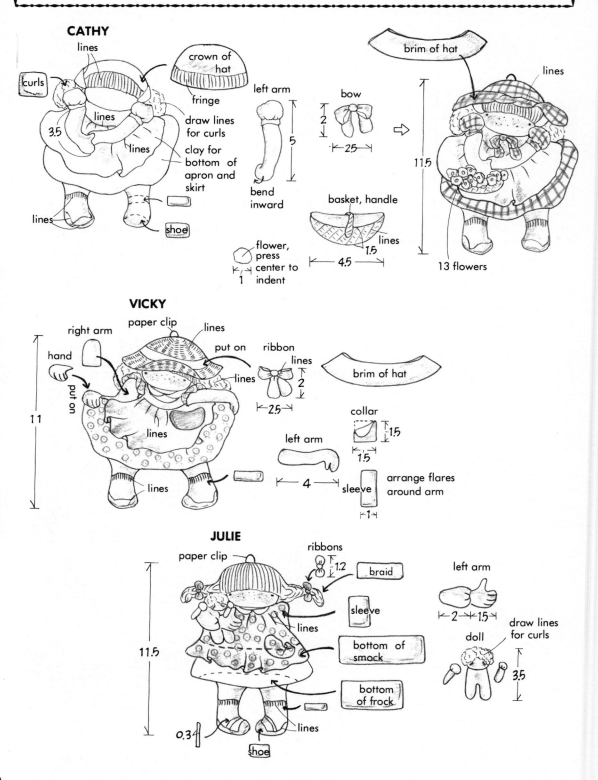

CATHY

lines

curls

crown of hat

fringe

draw lines for curls

clay for bottom of apron and skirt

3.5

lines

lines

lines

shoe

left arm

5

bend inward

bow

2

2.5

flower, press center to indent

1

basket, handle

lines

1.5

4.5

brim of hat

lines

11.5

13 flowers

VICKY

right arm

hand

put on

11

paper clip

lines

put on

lines

lines

lines

ribbon

lines

2

2.5

brim of hat

collar

1.5

1.5

left arm

4

sleeve

1

arrange flares around arm

JULIE

paper clip

ribbons

1.2

braid

sleeve

lines

bottom of smock

bottom of frock

11.5

lines

0.3

shoe

left arm

2 1.5

doll

draw lines for curls

3.5

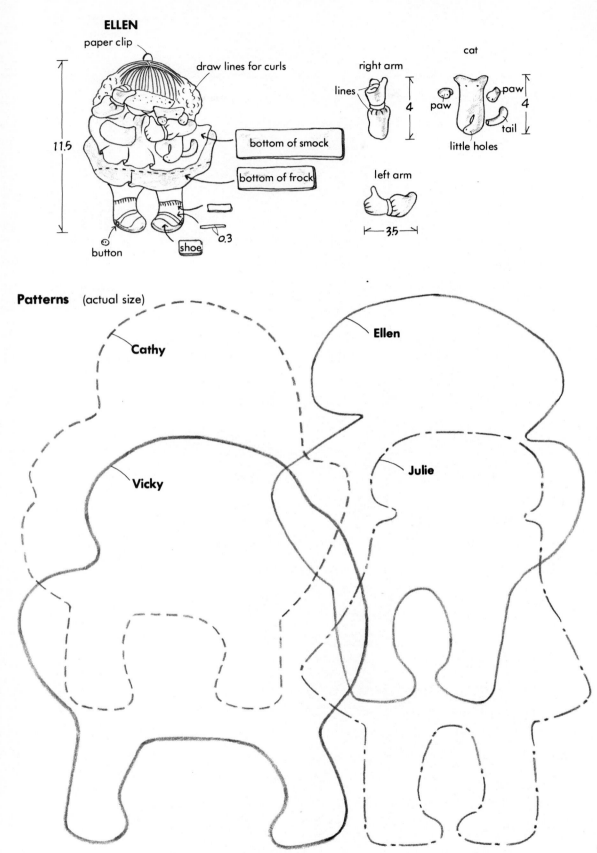

ELLEN

paper clip

draw lines for curls

11.5

bottom of smock

bottom of frock

button

shoe

0.3

right arm

lines

4

left arm

3.5

cat

paw

paw

tail

4

little holes

Patterns (actual size)

Cathy

Ellen

Vicky

Julie

MY WONDERLAND ANIMALS

Wall Ornaments

"Later..."

"Can I have some of that apple ? Please ?"

♥Squirrels in Love

"Goodnight"

"He's got a bone hidden... I wonder if he means to go on eating...?"

♥Brother and Sister Puppies

• See p.15 for how to make the squirrels and p.14 for how to make the puppies.

♥ Old Bear Friends

♥ Pigs' Wedding

• See p.15 for how to make the bears and p.86 for how to make the pigs.

13

Brother and Sister Puppies
p.12

For the pyjama stripes, paint the whole body in light blue and, when it has completely dried, draw in the stripes in darker blue. Put sweet little polka dots on the nightdress.

What to Use

wooden skewer
spatula
toothpick
water colours
½ packet of modelling clay (500g packet) for the pair
work base
lacquer
brushes
water
palette
towel

nightcap
3
1.5
crown
frills
1
ear
2
chin
frills
2.5
pocket
1.8
arm
3
1.3
bend slightly inwards
bottom of nightdress and frills

(A) build up so round bulges at front
small holes
10.5
arrange gathers
nose
0.7
pocket
lines
arrange a few gathers

(B)
9.5
put on so raised off arm
bone
2.5
put bone inside

Patterns
(actual size)

(A)

(B)

14

Squirrels in Love p.12

See p.14 for what to use

Make the apple round, then take a little bit of clay off with your fingers so that it looks as if a bite has already been taken out. Leave the bitten part unpainted so that the original clay color shows through.

paper clip

tail

roll inward

chin

lines

skirt

roll out thinly

Patterns
(actual size)

Ⓐ

Ⓑ

nose

Ⓐ

1.5

apple

line

remove some clay

←1.5→

9.5

lines

arrange flares
and put on body

Ⓑ

lines

chin

arm

raise
neckline
off body

happy

shirt

3.5

9.5

lines

← 6.5 →

lines

Old Bear Friends p.13

See p.14 for what to use

For ears, press slightly with finger to indent and use different color from face to give impression of the outside and the inside of the ear. Make the girl's ribbon separatley and put on later.

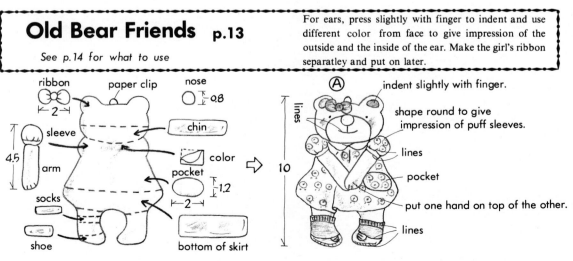

ribbon

paper clip

nose

0.8

chin

←2→

sleeve

4.5

arm

color

pocket

1.2

socks

←2→

shoe

bottom of skirt

Ⓐ

lines

indent slightly with finger.

shape round to give
impression of puff sleeves.

lines

pocket

put one hand on top of the other.

lines

10

For remaining illustrations and patterns, see p.87

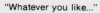

"Whatever you like..."

"Shall we go and have tea ? Or go to a film ?"

♥ Dating Panda Couple

"I caught a fish. Go on, have half."

"Thank you. Ummm. Looks good."

♥ Young Mr. & Mrs. Cat

● See p.18 for how to make the pandas and p.19 for how to make the cats.

♥Loving Foxes

♥Kitten Kindergarten

• See p.18 for how to make the foxes and p.90 for how to make the kittens.

Dating Panda Couple p.16

See p.14 for what to use

For the patterns on the boy's jumper, draw the diagonal lines for the check, color the diamond you get where the lines cross a darker brown and finally put in the white lines.

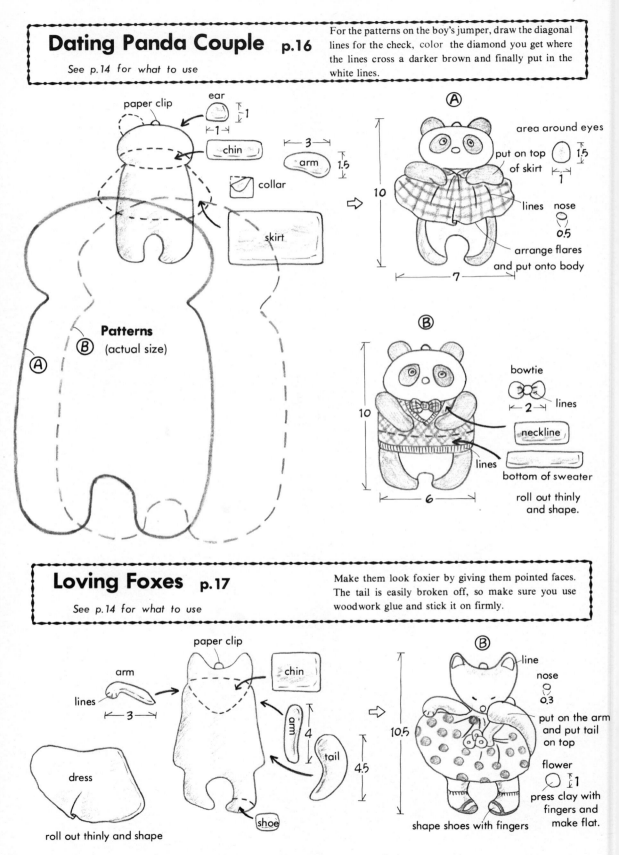

paper clip

ear
1
1

chin

3
arm
1.5

collar

skirt

Patterns
Ⓑ (actual size)

Ⓐ

Ⓐ

Ⓐ

area around eyes

put on top of skirt
1.5
1

10

lines
nose
0.5

arrange flares and put onto body

7

Ⓑ

10

bowtie
2
lines

neckline

lines

bottom of sweater

6

roll out thinly and shape.

Loving Foxes p.17

See p.14 for what to use

Make them look foxier by giving them pointed faces. The tail is easily broken off, so make sure you use woodwork glue and stick it on firmly.

paper clip

arm
lines
3

chin

arm
4

tail
4.5

dress

shoe

roll out thinly and shape

Ⓑ

line
nose
0.3

put on the arm and put tail on top

flower
1

press clay with fingers and make flat.

shape shoes with fingers

10.5

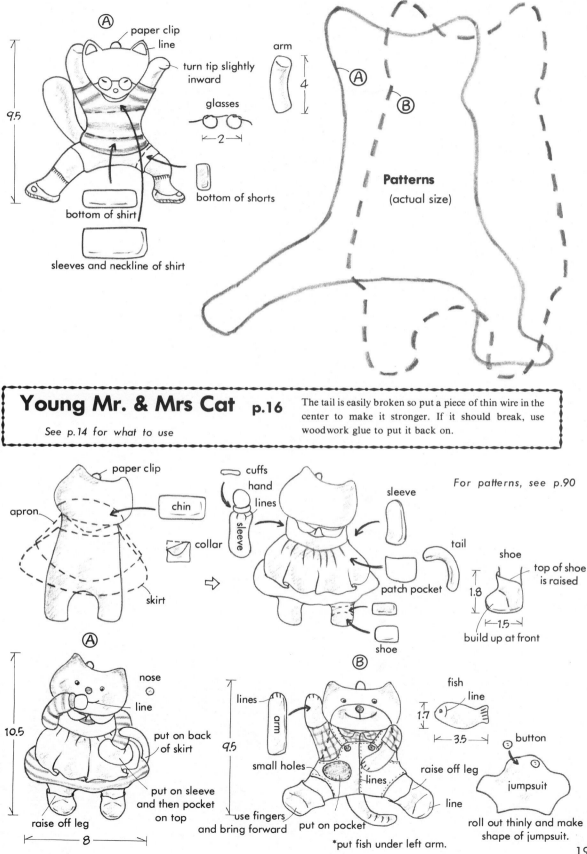

A

paper clip
line
turn tip slightly
inward

9.5

glasses

⊢ 2 ⊣

arm

4

bottom of shorts

bottom of shirt

sleeves and neckline of shirt

A
B

Patterns
(actual size)

Young Mr. & Mrs Cat p.16

See p.14 for what to use

The tail is easily broken so put a piece of thin wire in the center to make it stronger. If it should break, use woodwork glue to put it back on.

paper clip

apron

chin

collar

skirt

cuffs
hand
lines
sleeve
sleeve

sleeve

tail

patch pocket

shoe

shoe

For patterns, see p.90

top of shoe
is raised

1.8

⊢ 1.5 ⊣

build up at front

A

10.5

nose

line

put on back
of skirt

put on sleeve
and then pocket
on top

raise off leg

⊢ 8 ⊣

B

lines

arm

9.5

small holes

lines

use fingers
and bring forward

put on pocket

raise off leg

line

*put fish under left arm.

fish
line

1.7

⊢ 3.5 ⊣

button

jumpsuit

roll out thinly and make
shape of jumpsuit.

19

"Nobody takes any notice of me."

"I don't know how we managed to produce so many..."

"Please can I have that doll. Please. Please!"

chul

•See p.22 for details on how to make these.

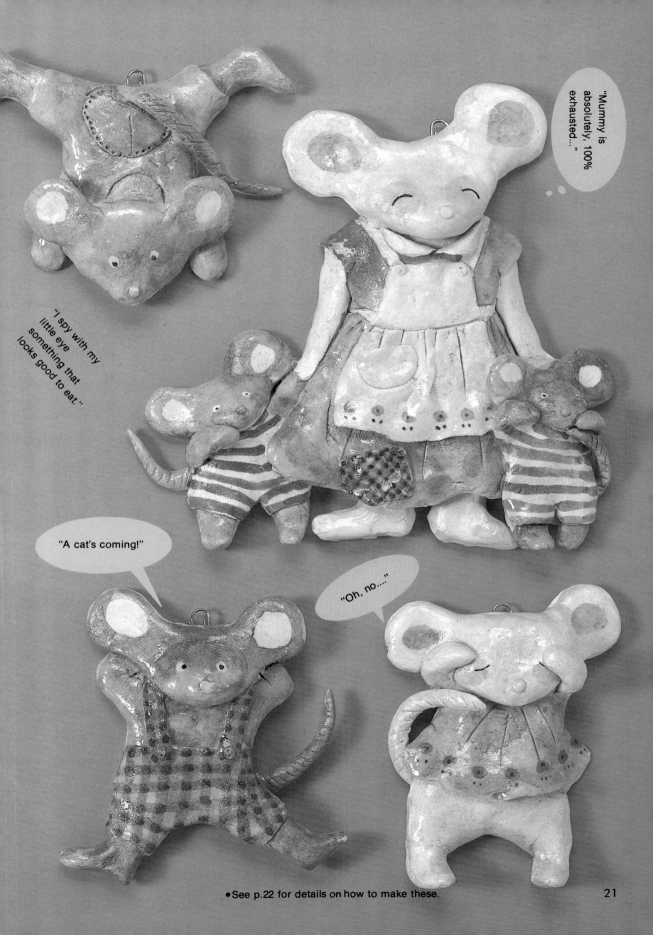

●See p.22 for details on how to make these.

The Mice Family of Attic Alley p.20, 21

The point about mice is their long tails. These are very easy to break, so put a piece of wire in the center and put onto the body using woodwork glue.

What to Use

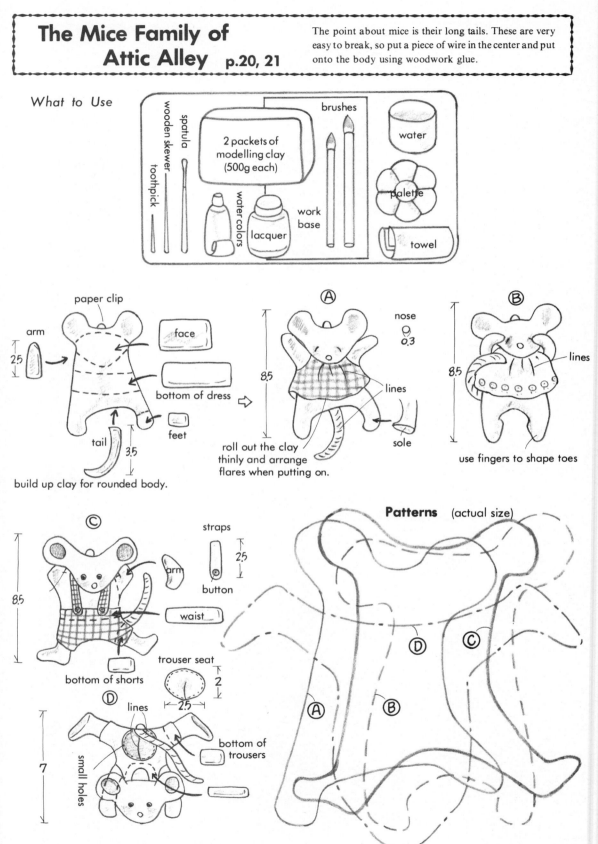

2 packets of modelling clay (500g each)

wooden skewer
spatula
toothpick
water colors
lacquer
brushes
water
palette
work base
towel

paper clip
arm
2.5
face
bottom of dress
feet
tail
3.5
build up clay for rounded body.

Ⓐ
nose
0.3
8.5
lines
sole
roll out the clay thinly and arrange flares when putting on.

Ⓑ
8.5
lines
use fingers to shape toes

Ⓒ
8.5
straps
2.5
arm
button
waist
trouser seat
2
2.5
bottom of shorts

Ⓓ
lines
small holes
7
bottom of trousers

Patterns (actual size)

Ⓓ Ⓒ
Ⓐ Ⓑ

22

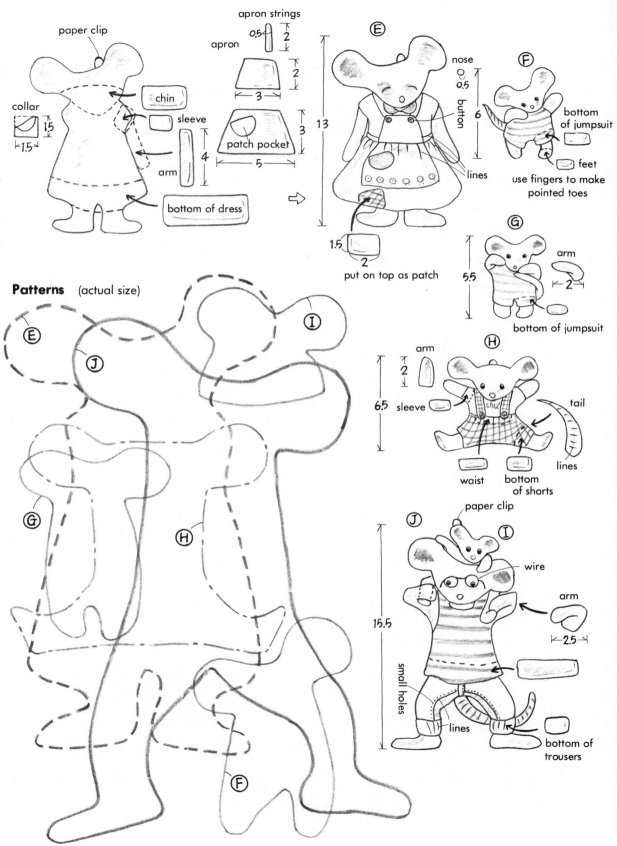

paper clip

collar

1.5
1.5

chin

sleeve

arm

4

bottom of dress

apron strings

0.5 2

apron

2

3

patch pocket

3

5

13

E

nose
0.5

button

6

lines

F

bottom of jumpsuit

feet

use fingers to make pointed toes

1.5

2

put on top as patch

G

5.5

arm
2

bottom of jumpsuit

H

arm
2

6.5 sleeve

tail

waist

bottom of shorts

lines

Patterns (actual size)

E

J

I

G

H

F

J

paper clip

I

wire

arm

2.5

15.5

small holes

lines

bottom of trousers

23

"Have a good day at the office"

"Right, I'm off!"

"Don't forget to get me a little present."

"Please come home early and help me with my homework."

"Let's try making a plastic model together tonight."

♥ Rabbit Family on the Estate

• See p.26 for details on how to make these.

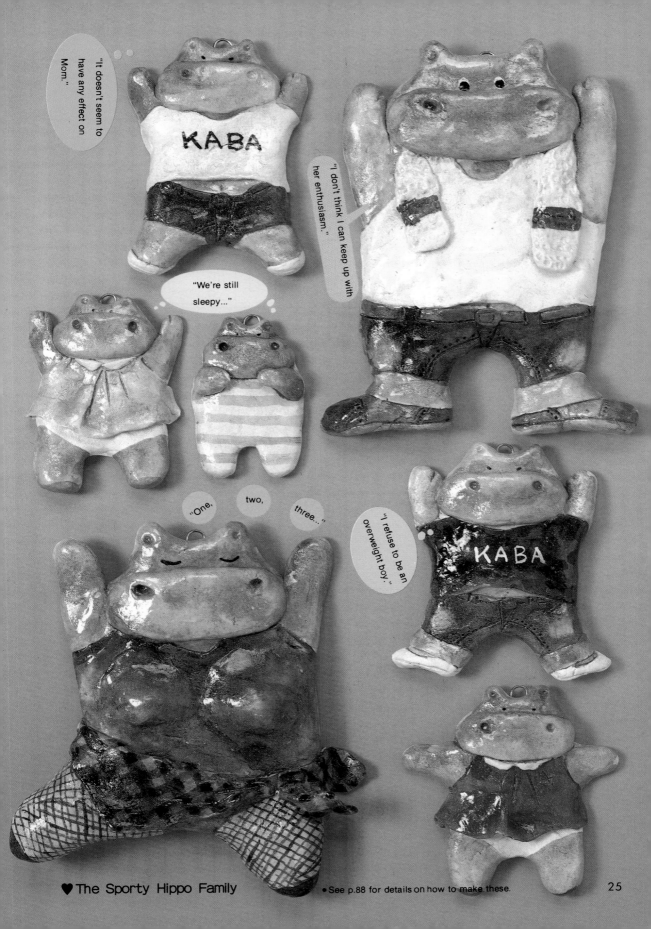

♥ The Sporty Hippo Family • See p.88 for details on how to make these. 25

Rabbit Family on the Estate

p.24

Make the father's glasses with a piece of thin wire and stick into the clay while it is soft. In order to make him look fatter, make the face wider.

What to Use

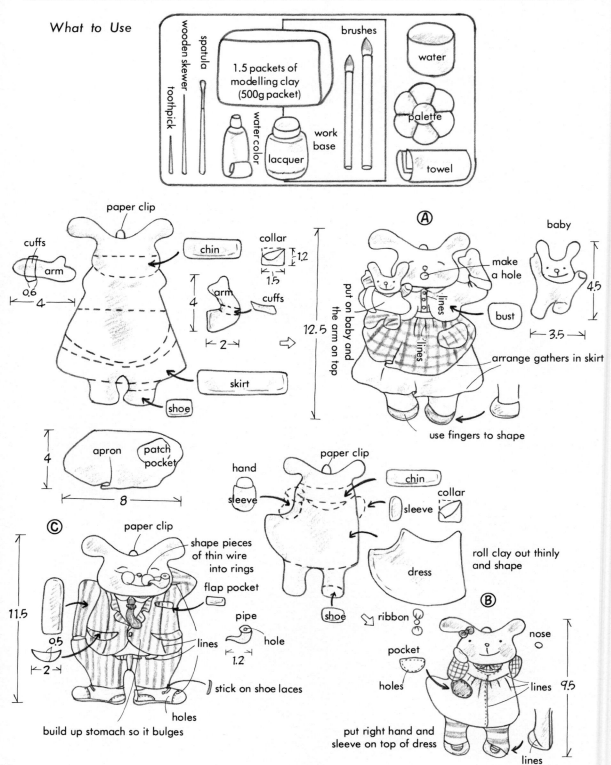

wooden skewer
spatula
toothpick
water color
lacquer
1.5 packets of modelling clay (500g packet)
brushes
work base
water
palette
towel

paper clip
cuffs
arm
0.6
4
chin
collar
1.2
1.5
arm
cuffs
4
2
12.5
put on baby and the arm on top
skirt
shoe

Ⓐ
make a hole
lines
bust
lines
lines
arrange gathers in skirt
use fingers to shape

baby
4.5
3.5

4
apron
patch pocket
8

Ⓒ
paper clip
shape pieces of thin wire into rings
flap pocket
pipe
hole
1.2
11.5
0.5
2
lines
stick on shoe laces
holes
build up stomach so it bulges

hand
sleeve
paper clip
chin
collar
sleeve
dress
roll clay out thinly and shape
shoe
ribbon

Ⓑ
nose
pocket
holes
lines
9.5
put right hand and sleeve on top of dress
lines

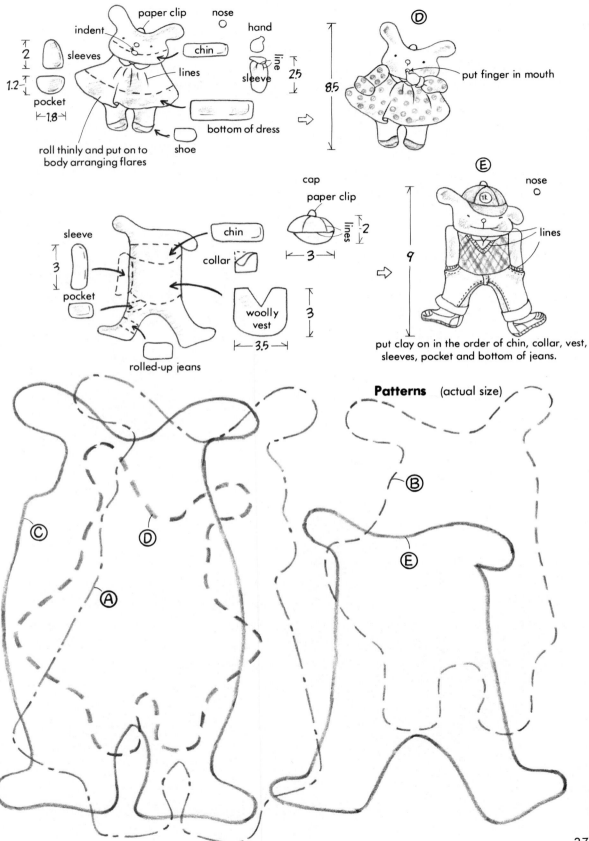

paper clip

nose
○

indent

sleeves

chin

hand

2

1.2

pocket

1.8

lines

lines

sleeve

2.5

8.5

⇨

roll thinly and put on to
body arranging flares

shoe

bottom of dress

Ⓓ

put finger in mouth

cap
paper clip

lines

2

3

Ⓔ

nose
○

lines

sleeve

3

chin

collar

pocket

woolly
vest

3

9

⇨

3.5

rolled-up jeans

put clay on in the order of chin, collar, vest,
sleeves, pocket and bottom of jeans.

Patterns (actual size)

Ⓑ

Ⓒ

Ⓓ

Ⓔ

Ⓐ

The Romantic Dreamworld Girls
Standing dolls

Illustrated in "Let's Make..." pages

BETH

MICHELE

FRANÇOISE

ANNE

• See p.76 for how to make Beth, p.30 for Michele, Françoise and Anne.

28

Little dolls (approx. 12 cm.) to stand on the windowsill or on a table. When putting in the patchwork or the floral patterns, wait until the color you put on before dries. The way to make Beth is shown in detail on p.76, so refer to it when making the other dolls, too.

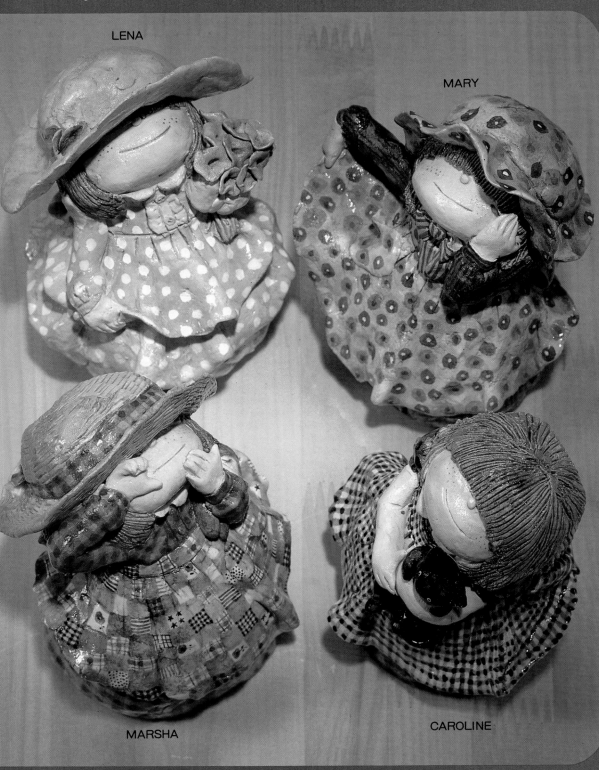

LENA

MARY

MARSHA

CAROLINE

•See p.31 for how to make Lena, Mary, Marsha and Caroline.

Standing Dolls p.28 29

Made in the same way as shown on p.76. Remove the stick you put inside the body when the clay has set a little, after about a day, and fill the hole with clay.

What to Use

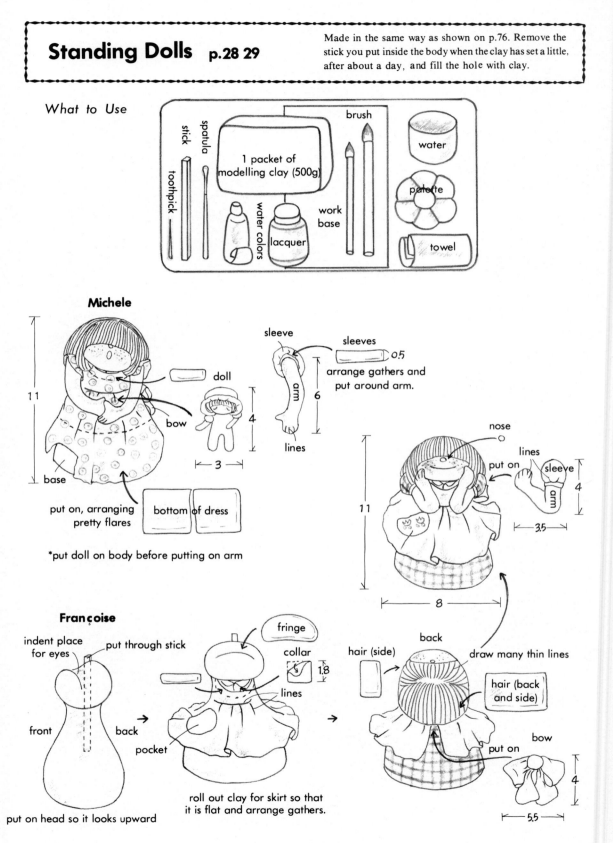

stick
spatula
toothpick
water colors
lacquer
brush
1 packet of modelling clay (500g)
work base
water
palette
towel

Michele

11

doll

bow

base

put on, arranging pretty flares

bottom of dress

*put doll on body before putting on arm

sleeve

sleeves 0.5
arrange gathers and put around arm.

arm 6

lines

4

3

nose

lines

put on

sleeve
arm 4

3.5

11

8

Françoise

indent place for eyes

put through stick

front back

put on head so it looks upward

fringe

collar 1.8

lines

pocket

roll out clay for skirt so that it is flat and arrange gathers.

back

hair (side)

draw many thin lines

hair (back and side)

bow

put on

4

5.5

30

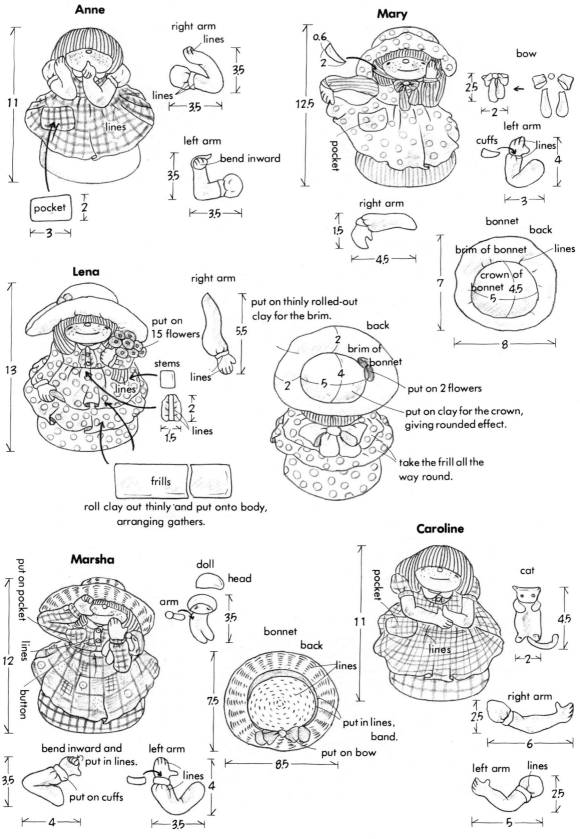

Anne

11

lines

pocket 2

⊢— 3 —⊣

right arm
lines

3.5

lines

⊢— 3.5 —⊣

left arm

bend inward

3.5

⊢— 3.5 —⊣

Mary

0.6

2

12.5

pocket

bow

2.5

⊢ 2 ⊣

left arm

cuffs lines

4

⊢— 3 —⊣

right arm

1.5

⊢— 4.5 —⊣

bonnet

back

brim of bonnet lines

crown of
bonnet 4.5

5

7

⊢———— 8 ————⊣

Lena

right arm

put on thinly rolled-out
clay for the brim.

5.5

lines

put on
15 flowers

stems

13

lines

2

1.5

lines

frills

roll clay out thinly and put onto body,
arranging gathers.

back

2

brim of
bonnet

2 4

2 5

put on 2 flowers

put on clay for the crown,
giving rounded effect.

take the frill all the
way round.

Marsha

put on pocket

lines

12

button

doll
head

arm

3.5

bonnet

back

lines

7.5

put in lines,
band.

⊢———— 8.5 ————⊣

put on bow

bend inward and
put in lines.

left arm

lines

3.5

put on cuffs

4

⊢— 4 —⊣

⊢— 3.5 —⊣

Caroline

pocket

11

lines

cat

4.5

⊢ 2 ⊣

right arm

2.5

⊢——— 6 ———⊣

left arm lines

2.5

⊢——— 5 ———⊣

31

Illustrated in
"Let's make..." pages

• See p.78 for details on
how to make these.

"We have guests today, so please help me in the kitchen."

THE LIVELY YOUNG COUPLES
Wall Ornaments

"Make sure you get it on the flowers, won't you?"

• See p.93 for details on how to make these.

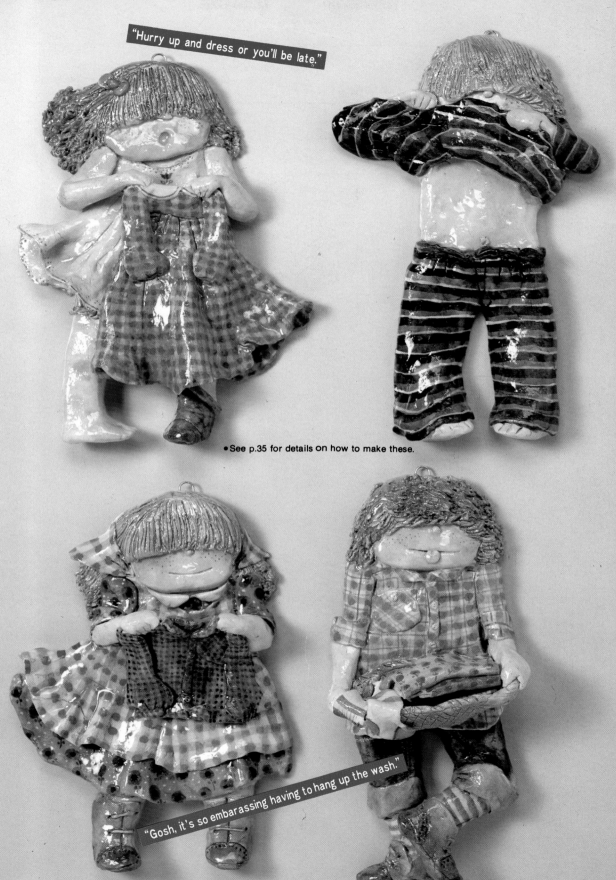

"Hurry up and dress or you'll be late."

• See p.35 for details on how to make these.

"Gosh, it's so embarassing having to hang up the wash."

• See p.34 for details on how to make these.

Wall Ornaments

Bottom of p.33

For the boy's basket, put the clay on his stomach, shape it into a basket and then draw the lines to make it look like one. Make the things that go inside separately and arrange them attractively later.

What to Use

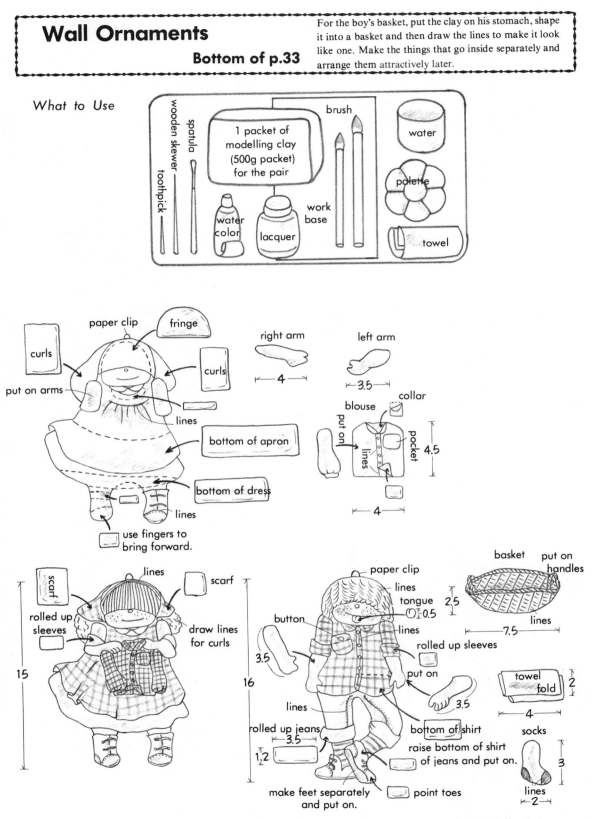

1 packet of modelling clay (500g packet) for the pair

wooden skewer
spatula
toothpick
water color
lacquer
work base
brush
water
palette
towel

paper clip
fringe
curls
curls
put on arms
lines
bottom of apron
bottom of dress
lines
use fingers to bring forward.

right arm
⊢—4—⊣

left arm
⊢—3.5—⊣

collar
blouse
put on
lines
pocket
4.5
⊢—4—⊣

scarf
lines
scarf
rolled up sleeves
draw lines for curls
15

paper clip
lines
tongue
0.5
lines
button
3.5
lines
rolled up sleeves
put on
3.5
bottom of shirt
raise bottom of shirt of jeans and put on.
lines
rolled up jeans
3.5
1.2
16
make feet separately and put on.
point toes

basket
put on handles
lines
⊢—7.5—⊣

towel
fold
2
⊢—4—⊣

socks
3
lines
⊢2⊣

See p.35 for patterns

34

Wall Ornaments Top of p.33

For what to use, see p.34.

Make the girl's dress separately and put into her hands later. Take care you make it so that it balances with the size of the body.

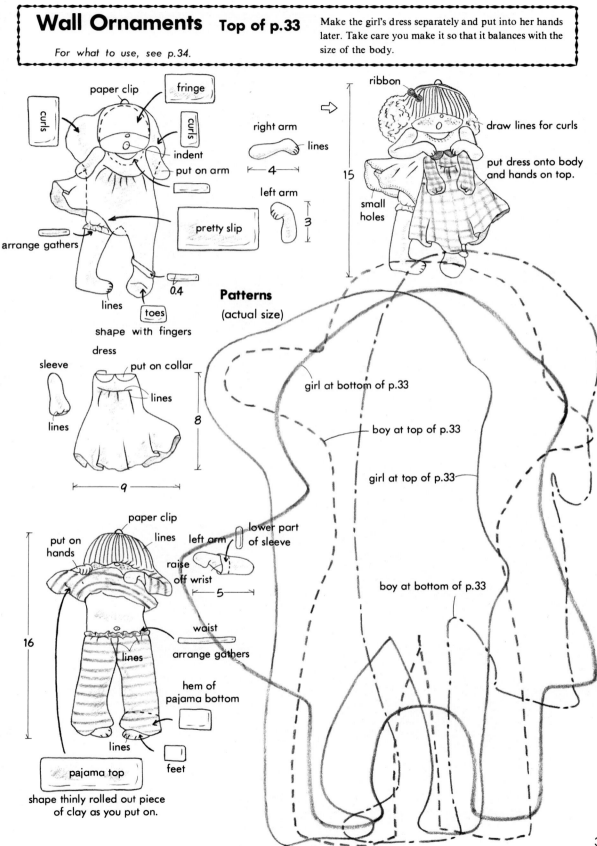

paper clip
fringe
curls
curls
indent
put on arm
arrange gathers
lines
0.4
toes
shape with fingers

right arm
lines
4
left arm
3

pretty slip

ribbon
draw lines for curls
put dress onto body and hands on top.
15
small holes

dress
sleeve
put on collar
lines
lines
8
9

Patterns
(actual size)

girl at bottom of p.33

boy at top of p.33

girl at top of p.33

boy at bottom of p.33

paper clip
lines
put on hands
left arm
lower part of sleeve
raise off wrist
5
waist
arrange gathers
16
lines
hem of pajama bottom
lines
pajama top
feet

shape thinly rolled out piece of clay as you put on.

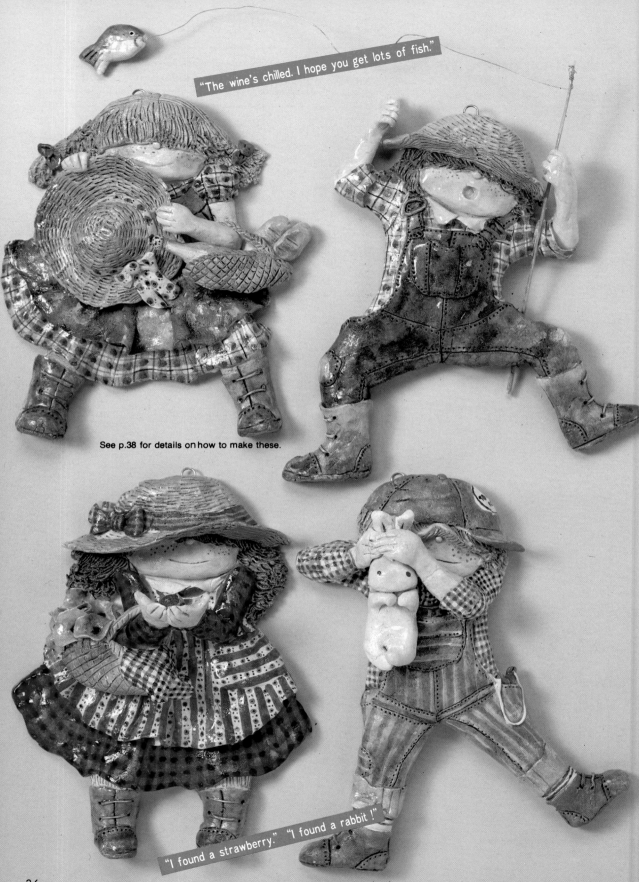

"The wine's chilled. I hope you get lots of fish."

See p.38 for details on how to make these.

"I found a strawberry." "I found a rabbit!"

See p.38 for details on how to make these.

36

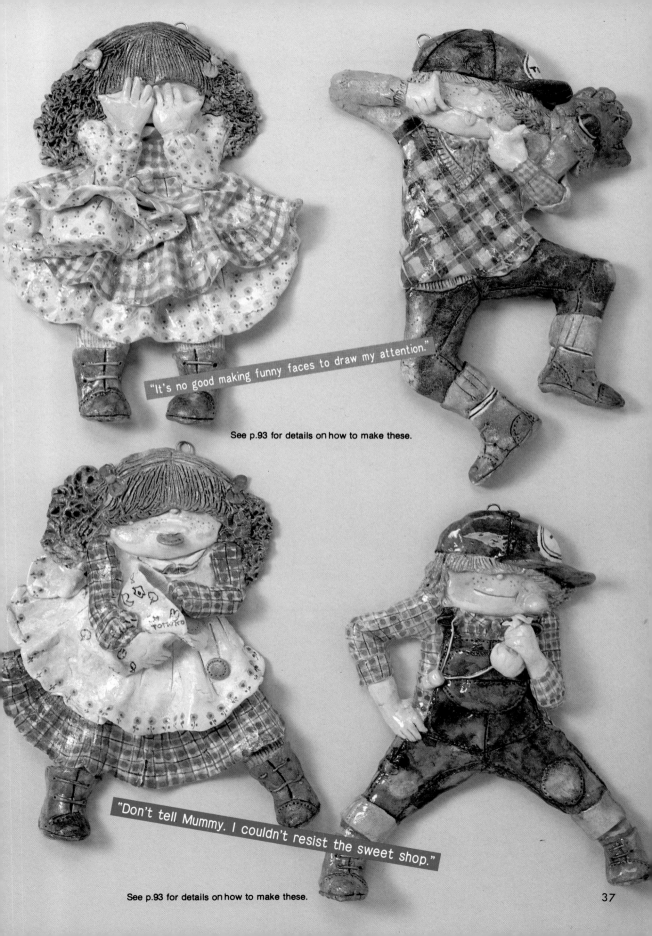

"It's no good making funny faces to draw my attention."

See p.93 for details on how to make these.

"Don't tell Mummy. I couldn't resist the sweet shop."

See p.93 for details on how to make these.

37

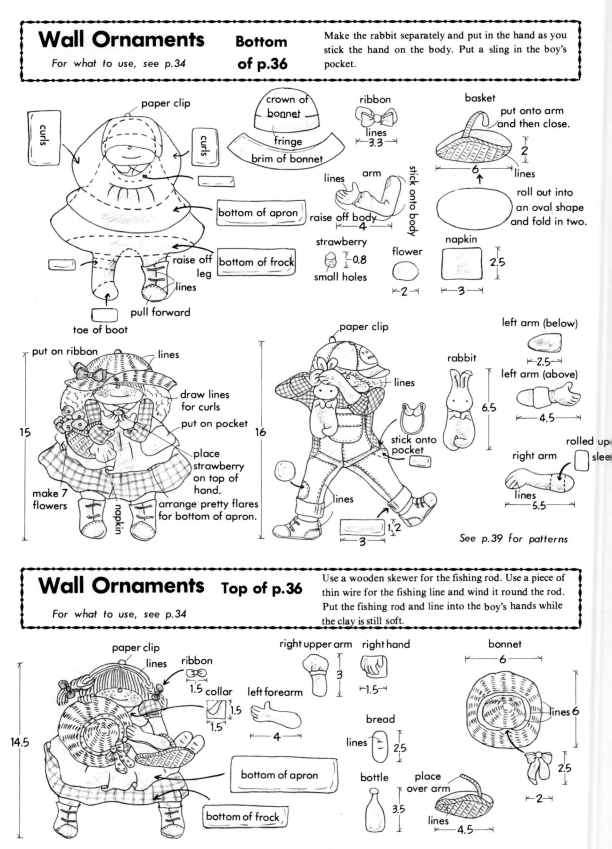

Wall Ornaments

Bottom of p.36

For what to use, see p.34

Make the rabbit separately and put in the hand as you stick the hand on the body. Put a sling in the boy's pocket.

paper clip

curls

curls

crown of bonnet

fringe

brim of bonnet

ribbon

lines 3.3

basket

put onto arm and then close.

2

6 lines

roll out into an oval shape and fold in two.

bottom of apron

arm

lines

raise off body 4

stick onto body

strawberry 0.8 small holes

flower

napkin 2.5

bottom of frock

2

3

raise off leg

lines

pull forward

toe of boot

put on ribbon

lines

draw lines for curls

put on pocket

place strawberry on top of hand.

make 7 flowers

napkin

arrange pretty flares for bottom of apron.

15

16

paper clip

lines

rabbit

6.5

stick onto pocket

lines

1.2

3

left arm (below) 2.5

left arm (above) 4.5

rolled up sleeve

right arm

lines 5.5

See p.39 for patterns

Wall Ornaments

Top of p.36

For what to use, see p.34

Use a wooden skewer for the fishing rod. Use a piece of thin wire for the fishing line and wind it round the rod. Put the fishing rod and line into the boy's hands while the clay is still soft.

paper clip

lines

ribbon

1.5 collar

1.5

1.5

right upper arm

left forearm

4

right hand

1.5

bread

lines 2.5

bottle

3.5

3

bonnet

6

lines 6

2.5

2

place over arm

lines 4.5

14.5

bottom of apron

bottom of frock

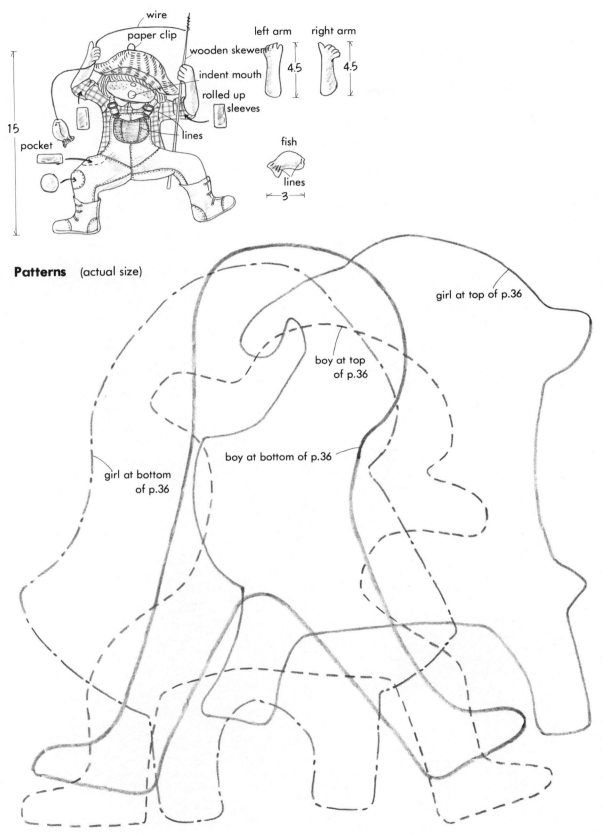

wire

paper clip

wooden skewer

indent mouth

rolled up
sleeves

lines

pocket

15

left arm right arm

4.5 4.5

fish

lines

3

Patterns (actual size)

girl at top of p.36

boy at top
of p.36

boy at bottom of p.36

girl at bottom
of p.36

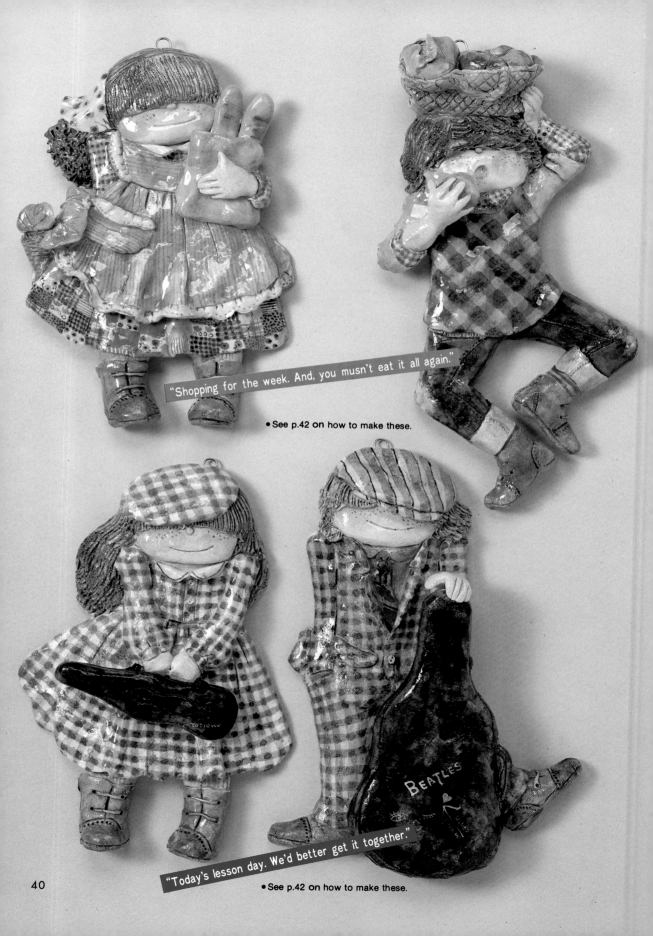

"Shopping for the week. And, you musn't eat it all again."

• See p.42 on how to make these.

"Today's lesson day. We'd better get it together."

• See p.42 on how to make these.

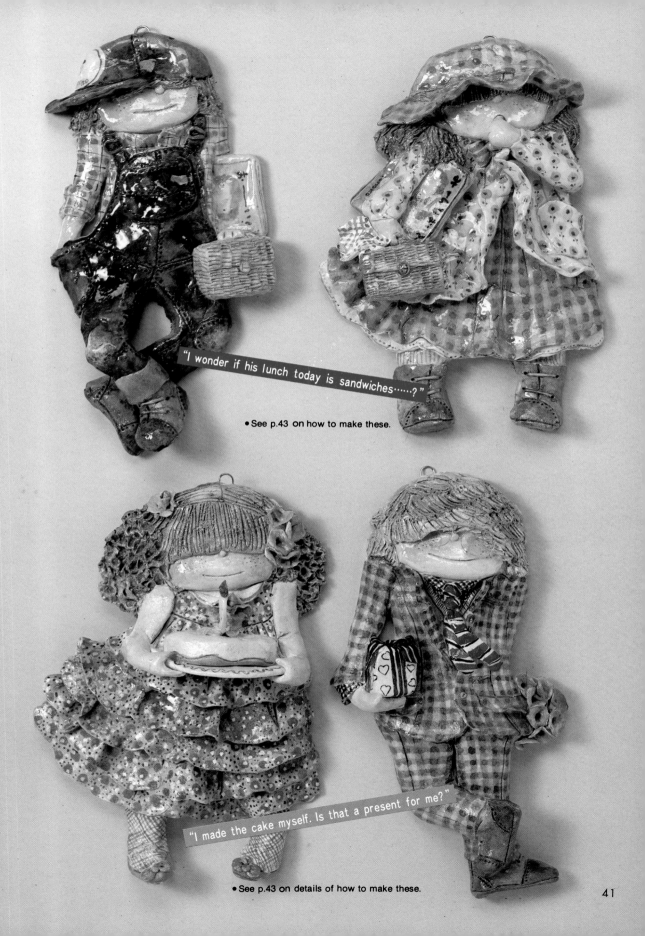

"I wonder if his lunch today is sandwiches······?"

● See p.43 on how to make these.

"I made the cake myself. Is that a present for me?"

● See p.43 on details of how to make these.

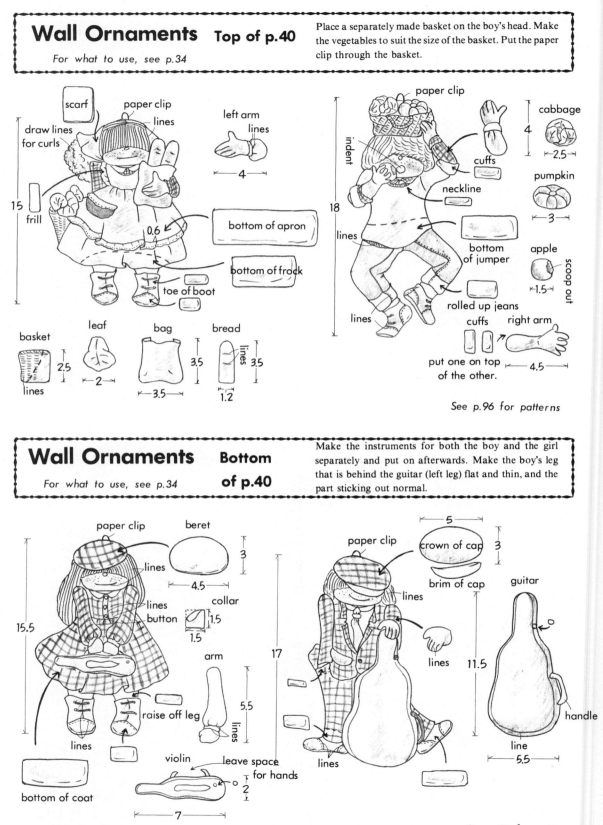

Wall Ornaments Top of p.40

For what to use, see p.34

Place a separately made basket on the boy's head. Make the vegetables to suit the size of the basket. Put the paper clip through the basket.

scarf

paper clip

lines

draw lines for curls

left arm

lines

15

frill

0.6

bottom of apron

bottom of frock

toe of boot

4

paper clip

cabbage

indent

cuffs

neckline

18

lines

bottom of jumper

lines

rolled up jeans

cuffs

lines

4

2.5

pumpkin

3

apple

1.5

scoop out

right arm

put one on top of the other.

4.5

basket

2.5

lines

leaf

2

bag

3.5

3.5

bread

lines

3.5

1.2

See p.96 for patterns

Wall Ornaments Bottom of p.40

For what to use, see p.34

Make the instruments for both the boy and the girl separately and put on afterwards. Make the boy's leg that is behind the guitar (left leg) flat and thin, and the part sticking out normal.

paper clip

beret

3

lines

4.5

lines

button

collar

1.5

1.5

15.5

arm

5.5

lines

raise off leg

lines

bottom of coat

violin

leave space for hands

2

7

paper clip

5

crown of cap

3

lines

brim of cap

guitar

17

11.5

lines

handle

lines

line

5.5

See p.96 for patterns

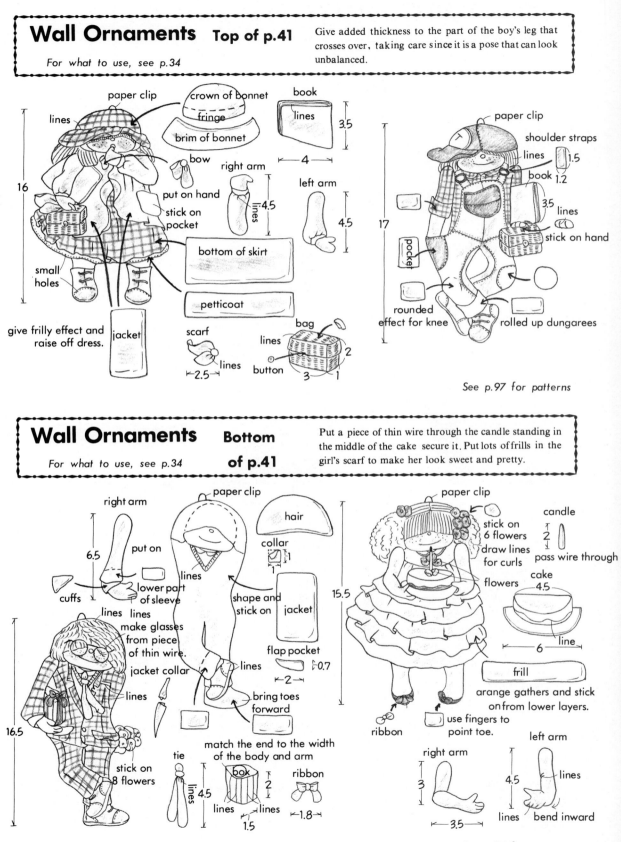

Wall Ornaments Top of p.41

For what to use, see p.34

Give added thickness to the part of the boy's leg that crosses over, taking care since it is a pose that can look unbalanced.

paper clip
lines
crown of bonnet
fringe
brim of bonnet
book
lines
3.5
4
bow
put on hand
stick on pocket
right arm
lines
4.5
left arm
4.5
bottom of skirt
petticoat
16
small holes
give frilly effect and raise off dress.
jacket
scarf
lines
2.5
bag
lines
button
2
3 1

paper clip
shoulder straps
lines
1.5
book
1.2
3.5
lines
stick on hand
pocket
17
rounded effect for knee
rolled up dungarees

See p.97 for patterns

Wall Ornaments Bottom of p.41

For what to use, see p.34

Put a piece of thin wire through the candle standing in the middle of the cake secure it. Put lots of frills in the girl's scarf to make her look sweet and pretty.

right arm
6.5
put on
cuffs
lower part of sleeve
lines lines
make glasses from piece of thin wire.
jacket collar
lines
16.5
stick on 8 flowers

paper clip
hair
collar
1
lines
shape and stick on
jacket
flap pocket
0.7
lines
2
bring toes forward
15.5

match the end to the width of the body and arm
tie
lines
4.5
box
2
lines lines
1.5
ribbon
1.8

paper clip
stick on 6 flowers
draw lines for curls
flowers
candle
2
pass wire through
cake
4.5
line
6
frill
arange gathers and stick on from lower layers.
ribbon
use fingers to point toe.
right arm
3
3.5
left arm
4.5
lines
lines bend inward

See p.97 for patterns 43

TREASURE TROVE OF TRINKETS

You can make these trinkets into brooches or use as little mascots. When you finish making them, put on several layers of lacquer, making sure that each layer is dry before you apply the next. They will be stronger and less likely to break.

These are actual sized photos, so make patterns from them.

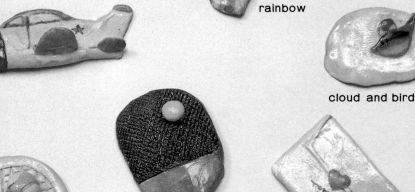

rainbow

airplane

cloud and bird

baseball bat

table tennis racket

love letter

tennis racket

pencils

cigarette

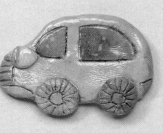

roller skates

cars

inside basket

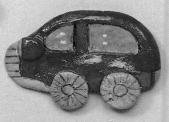

pram

basket

● See p.46 for details on how to make these.

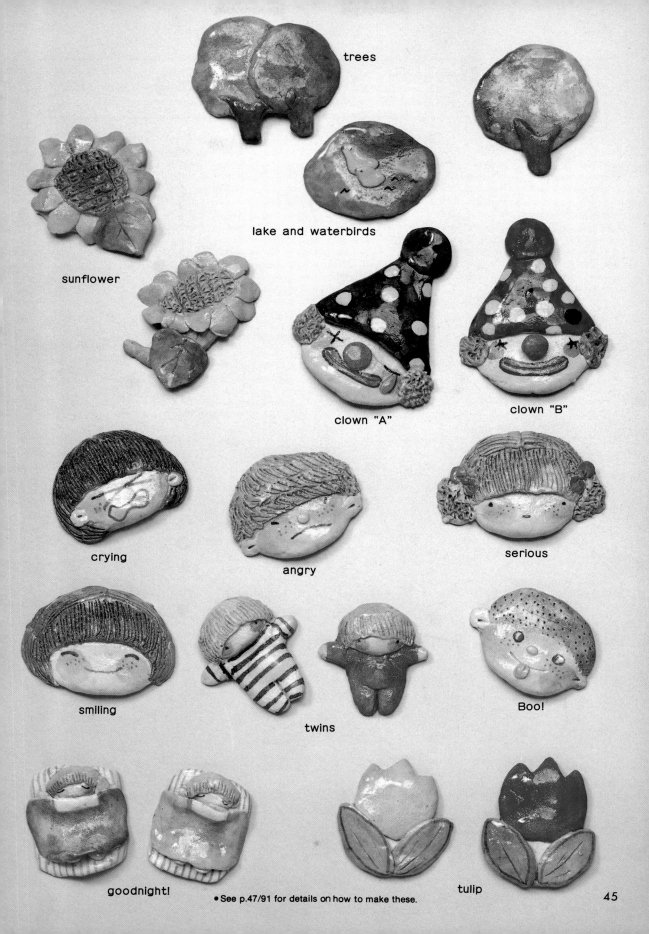

trees

lake and waterbirds

sunflower

clown "A"

clown "B"

crying

angry

serious

smiling

twins

Boo!

goodnight!

tulip

• See p.47/91 for details on how to make these.

45

Treasure Trove of Trinkets p.44

Sweet things that you can make with only a little bit of clay. You can stick a pin on the reverse side and make a brooch or use them as earrings and pendants.

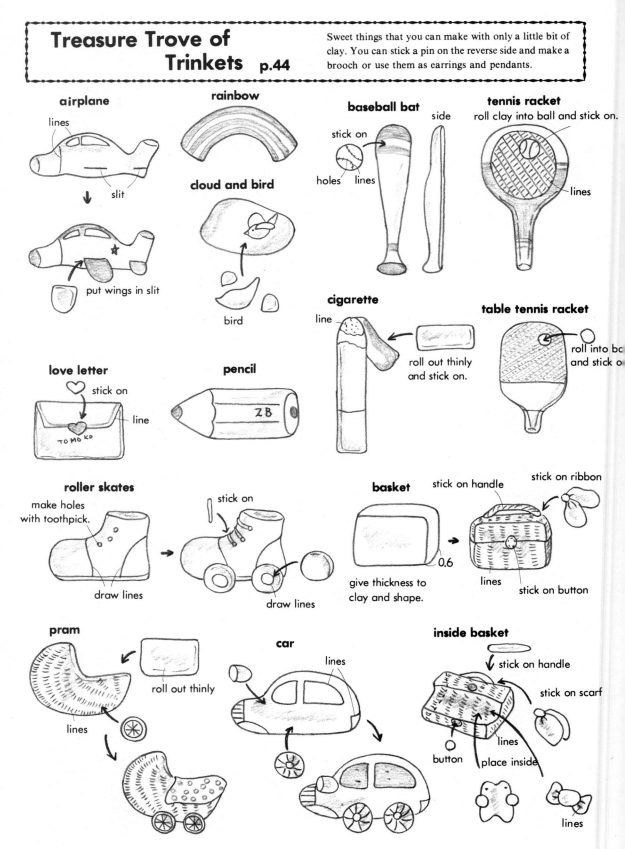

airplane
lines
slit
put wings in slit

rainbow

cloud and bird
bird

baseball bat
stick on
holes
lines
side

tennis racket
roll clay into ball and stick on.
lines

cigarette
line
roll out thinly and stick on.

table tennis racket
roll into ba[...] and stick o[...]

love letter
stick on
line
TO MO KO

pencil
2B

roller skates
make holes with toothpick.
draw lines
stick on
draw lines

basket
stick on handle
stick on ribbon
give thickness to clay and shape.
0.6
lines
stick on button

pram
roll out thinly
lines

car
lines

inside basket
stick on handle
stick on scarf
lines
button
place inside
lines

Trinkets p.45

Try making little mascots such as characters from picture books, animals, houses, scenes, etc. Make caricatures of members of your family. That's fun, too.

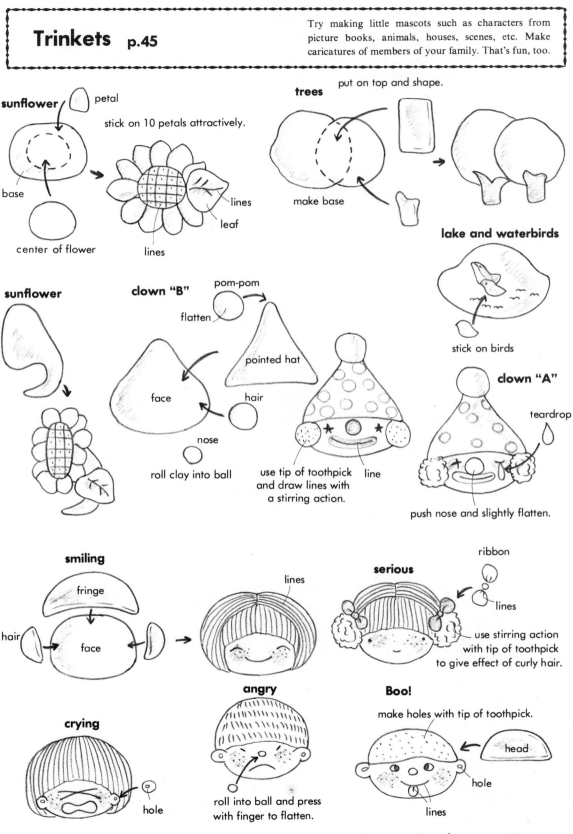

sunflower
petal
stick on 10 petals attractively.
base
lines
leaf
lines
center of flower

trees
put on top and shape.
make base

lake and waterbirds
stick on birds

sunflower

clown "B"
pom-pom
flatten
pointed hat
face
hair
nose
roll clay into ball
use tip of toothpick and draw lines with a stirring action.
line

clown "A"
teardrop
push nose and slightly flatten.

smiling
fringe
hair
face
lines

serious
ribbon
lines
use stirring action with tip of toothpick to give effect of curly hair.

crying
hole

angry
roll into ball and press with finger to flatten.

Boo!
make holes with tip of toothpick.
head
hole
lines

For others, see p.91

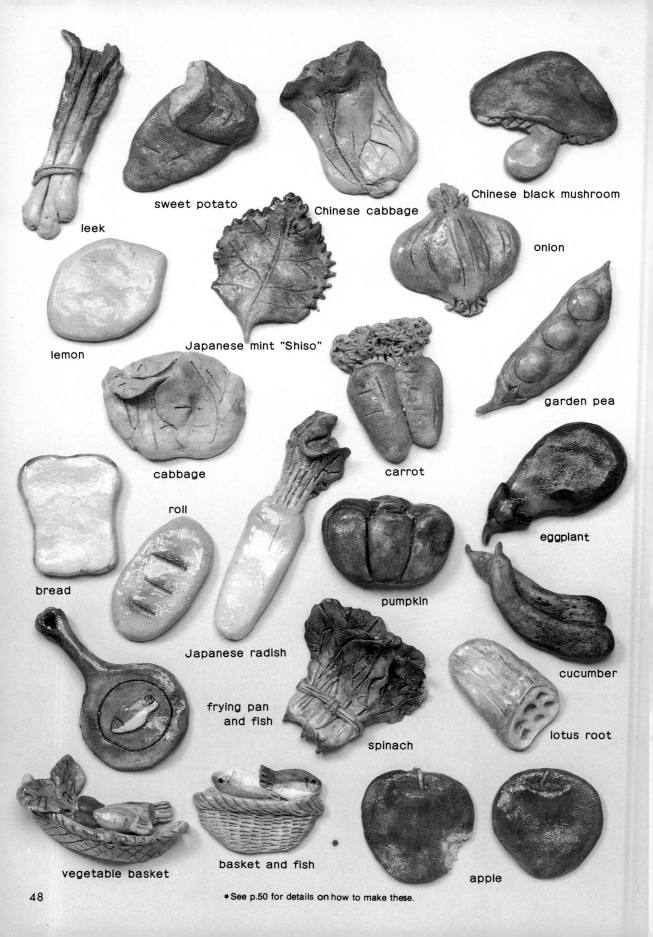

leek

sweet potato

Chinese cabbage

Chinese black mushroom

onion

lemon

Japanese mint "Shiso"

garden pea

cabbage

carrot

eggplant

bread

roll

pumpkin

Japanese radish

cucumber

frying pan and fish

spinach

lotus root

vegetable basket

basket and fish

apple

48

• See p.50 for details on how to make these.

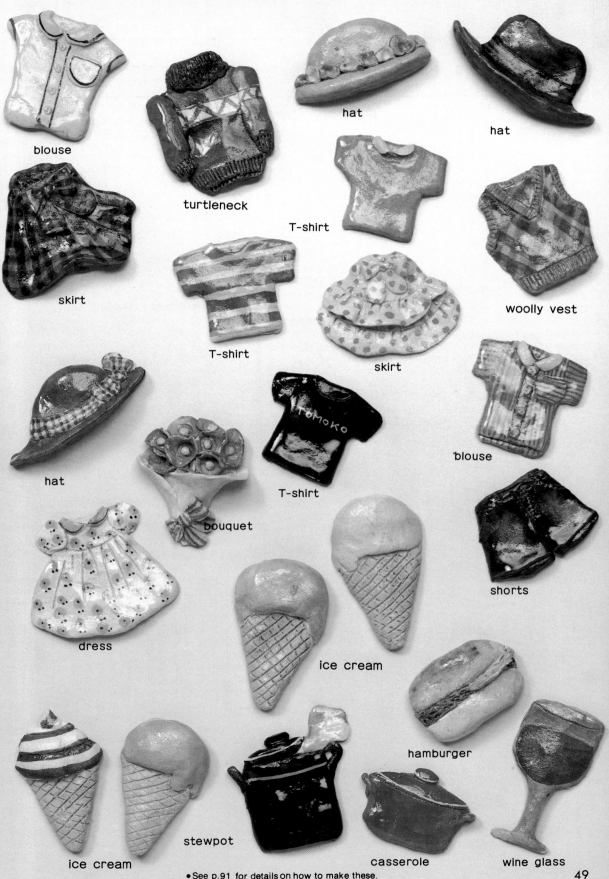

blouse

turtleneck

hat

hat

T-shirt

skirt

T-shirt

woolly vest

T-shirt

skirt

hat

bouquet

T-shirt

'blouse

shorts

dress

ice cream

ice cream

stewpot

hamburger

casserole

wine glass

• See p.91 for details on how to make these.

49

Trinkets p.48

Why don't you make dishes and food that you like and arrange a meal for yourself on a toy table? A wonderful make-believe meal...

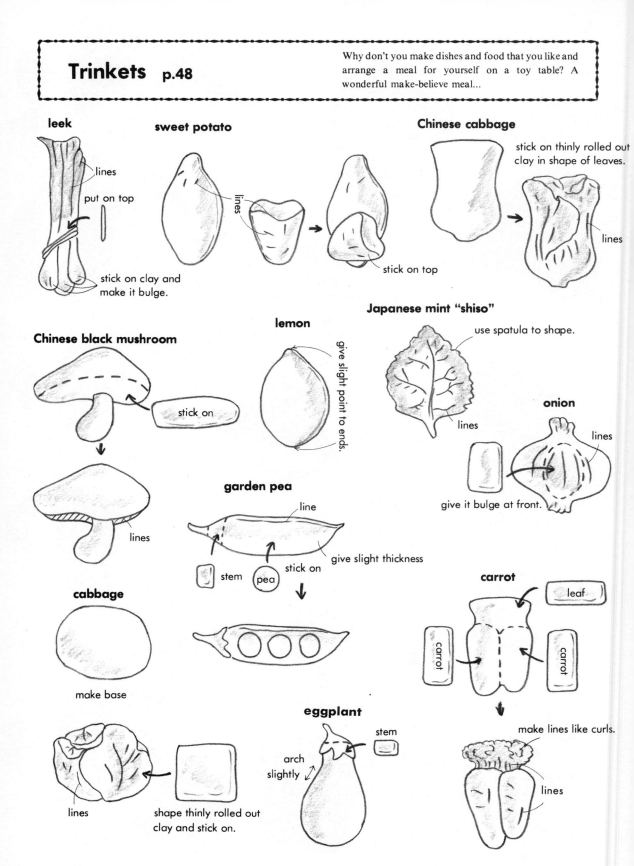

leek
lines
put on top
stick on clay and make it bulge.

sweet potato
lines
stick on top

Chinese cabbage
stick on thinly rolled out clay in shape of leaves.
lines

Chinese black mushroom
stick on
lines

lemon
give slight point to ends.

Japanese mint "shiso"
use spatula to shape.
lines

onion
lines
give it bulge at front.

garden pea
line
give slight thickness
stem
pea
stick on

cabbage
make base

carrot
leaf
carrot
carrot
make lines like curls.
lines

eggplant
stem
arch slightly
lines
shape thinly rolled out clay and stick on.

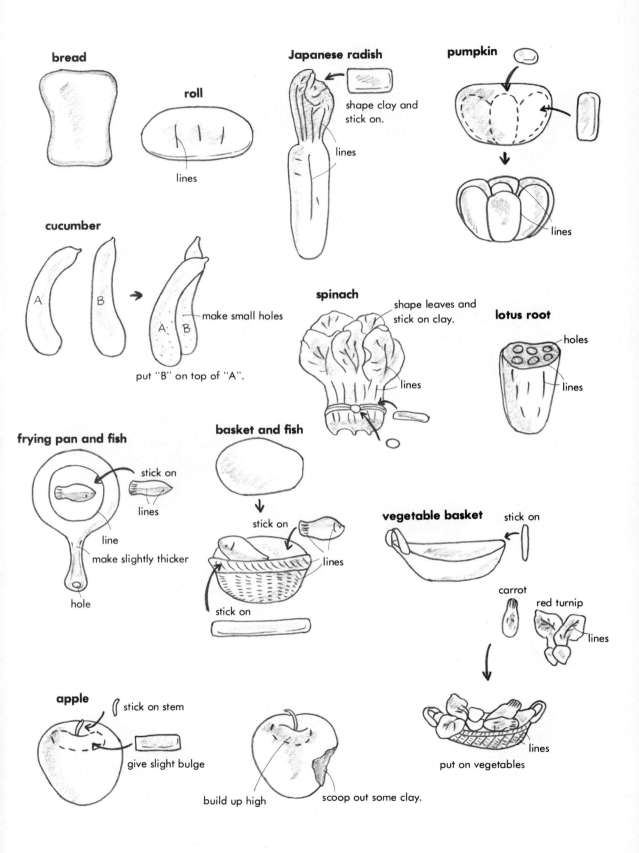

bread

roll

lines

Japanese radish

shape clay and stick on.

lines

pumpkin

lines

cucumber

A

B

A B — make small holes

put "B" on top of "A".

spinach

shape leaves and stick on clay.

lines

lotus root

holes

lines

frying pan and fish

stick on

lines

line

make slightly thicker

hole

basket and fish

stick on

lines

stick on

vegetable basket

stick on

carrot

red turnip

lines

put on vegetables

lines

apple

stick on stem

give slight bulge

build up high

scoop out some clay.

51

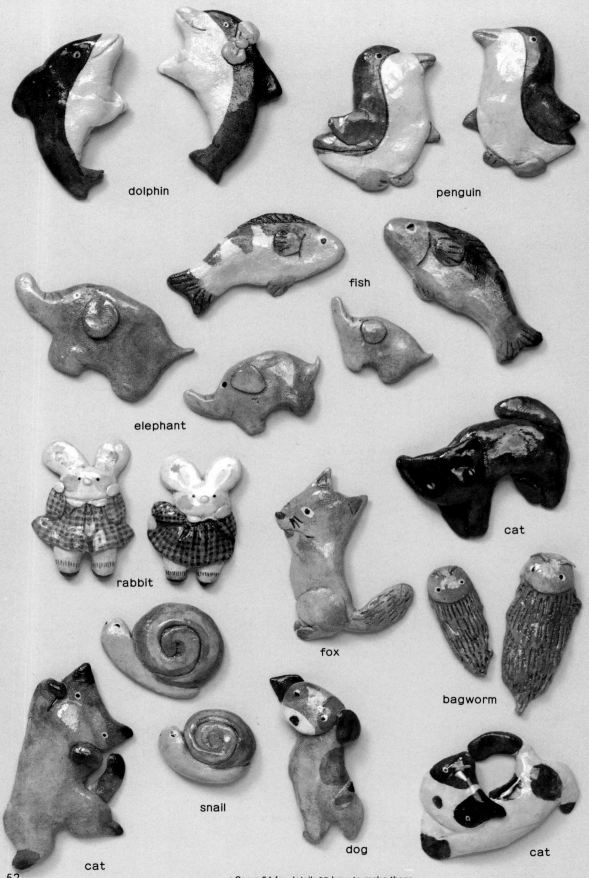

dolphin

penguin

fish

elephant

cat

rabbit

fox

bagworm

snail

dog

cat

cat

52

• See p.54 for details on how to make these.

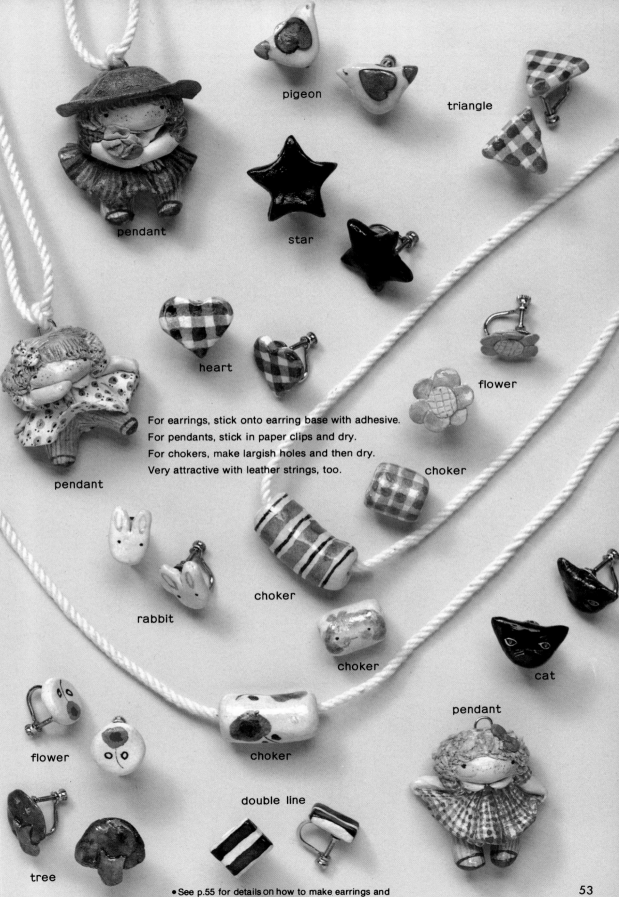

pigeon

triangle

pendant

star

heart

flower

For earrings, stick onto earring base with adhesive.
For pendants, stick in paper clips and dry.
For chokers, make largish holes and then dry.
Very attractive with leather strings, too.

choker

pendant

rabbit

choker

choker

cat

pendant

flower

choker

double line

tree

• See p.55 for details on how to make earrings and
p.98 for details on how to make pendants and chokers.

53

Trinkets p.52

You can make cats, dogs, birds, fish or anything else that's around you. Children are very fond of animals. Make lots of things with your mother.

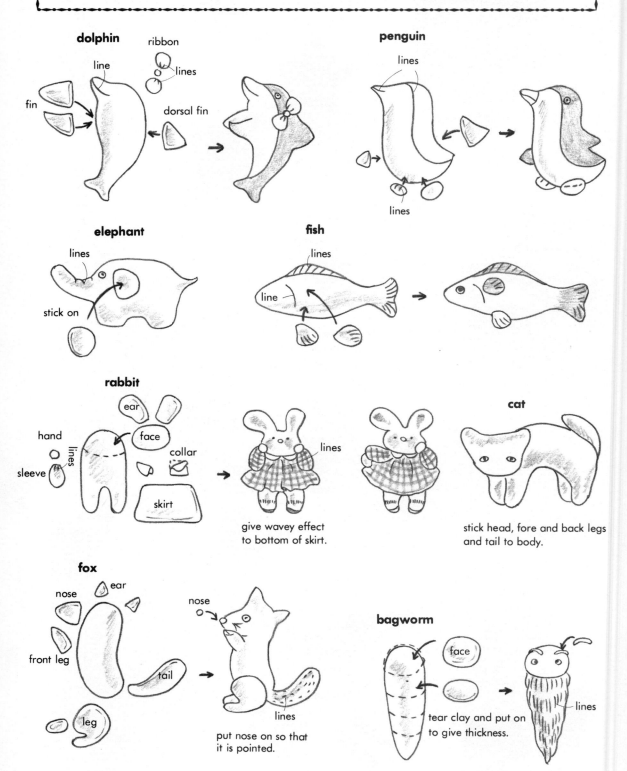

dolphin
ribbon
line
lines
fin
dorsal fin

penguin
lines
lines

elephant
lines
stick on

fish
lines
line

rabbit
ear
hand
face
sleeve
lines
collar
skirt
lines

give wavey effect to bottom of skirt.

cat
stick head, fore and back legs and tail to body.

fox
ear
nose
nose
front leg
tail
leg
lines

put nose on so that it is pointed.

bagworm
face
tear clay and put on to give thickness.
lines

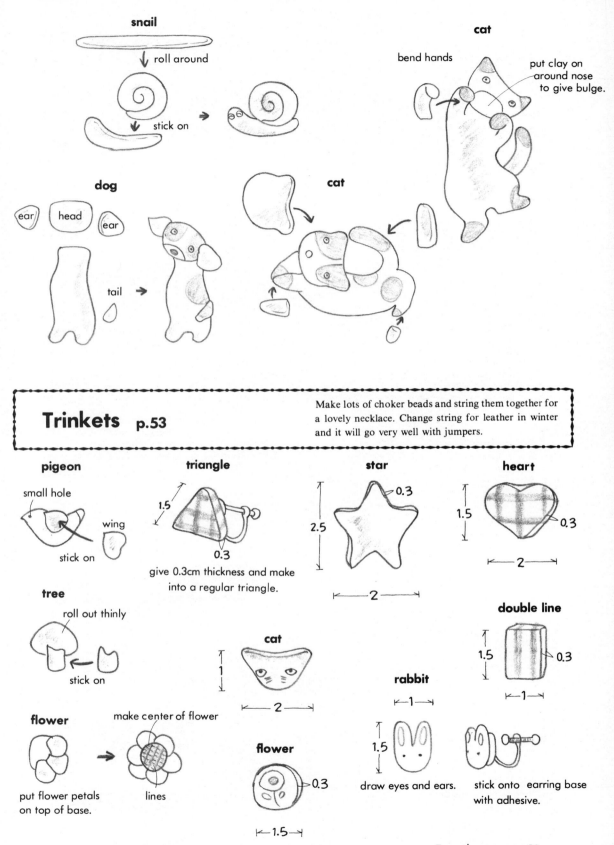

snail

roll around

stick on

dog

ear head ear

tail →

cat

bend hands

put clay on around nose to give bulge.

cat

Trinkets p.53

Make lots of choker beads and string them together for a lovely necklace. Change string for leather in winter and it will go very well with jumpers.

pigeon

small hole

wing

stick on

triangle

1.5

0.3

give 0.3cm thickness and make into a regular triangle.

star

0.3

2.5

2

heart

1.5

0.3

2

tree

roll out thinly

stick on

cat

1

2

double line

1.5

0.3

1

rabbit

1

1.5

draw eyes and ears.

stick onto earring base with adhesive.

flower

make center of flower

lines

put flower petals on top of base.

flower

0.3

1.5

For others, see p.98

Write your name and telephone number on the back with an oil-based felt tip pen and use a safety pin to wear on your clothes or bag. If you stand there lost and in tears, someone will notice you have the tag on. They are easy to make and can be sweet pendants, brooches or mascots. After it is dry, make sure you put on many layers of lacquer, waiting after each one so that it dries completely. That makes it less likely to break. The photographs show the actual size so take your pattern directly from them.

house

rabbit

boy

girl

fish

pig

mouse

bear

sheep

panda

●See p.58 for details on how to make these.

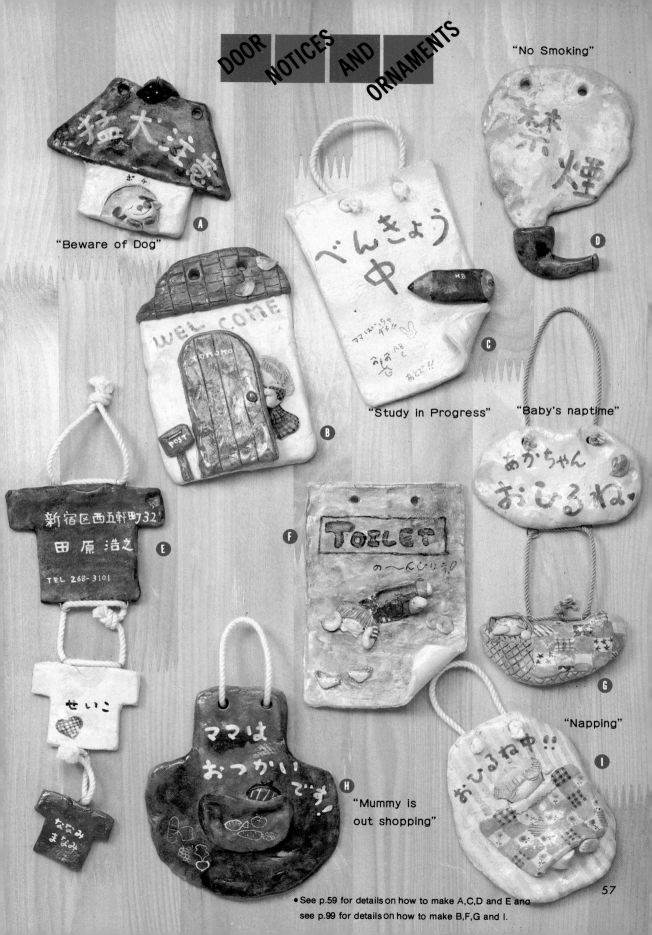

"No Smoking"

A "Beware of Dog"

D

B

C "Study in Progress"

"Baby's naptime"

E

新宿区西五軒町32
田原 浩之

TEL 268-3101

せいこ

F

TOILET
の～んびり初

G

I "Napping"

H "Mummy is out shopping"

● See p.59 for details on how to make A,C,D and E and see p.99 for details on how to make B,F,G and I.

Missing Child Tags p.56

Make the back flat so that you can write on it. As it is going to be worn, make sure you put many layers of lacquer on to make it strong.

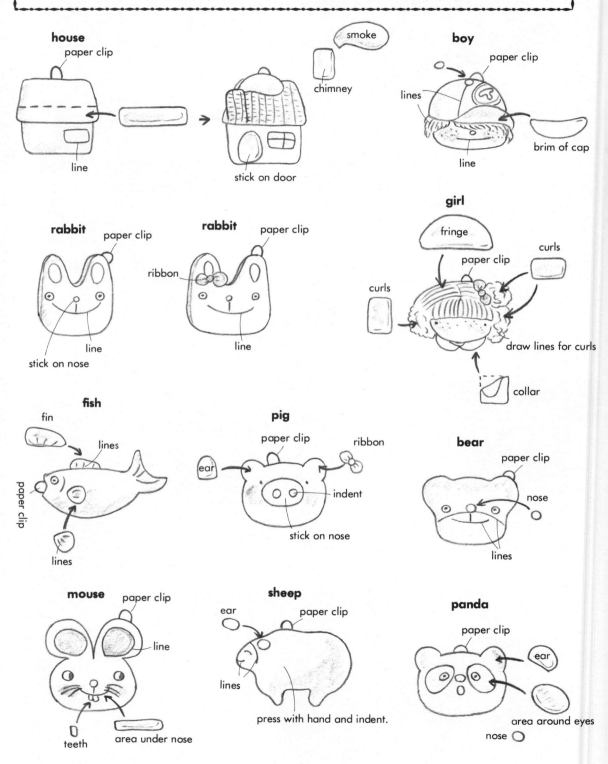

house
paper clip
line
smoke
chimney
stick on door

boy
paper clip
lines
brim of cap
line

rabbit
paper clip
line
stick on nose

rabbit
paper clip
ribbon
line

girl
fringe
paper clip
curls
curls
draw lines for curls
collar

fish
fin
lines
paper clip
lines

pig
paper clip
ribbon
ear
indent
stick on nose

bear
paper clip
nose
lines

mouse
paper clip
line
teeth
area under nose

sheep
ear
paper clip
lines
press with hand and indent.

panda
paper clip
ear
area around eyes
nose

58

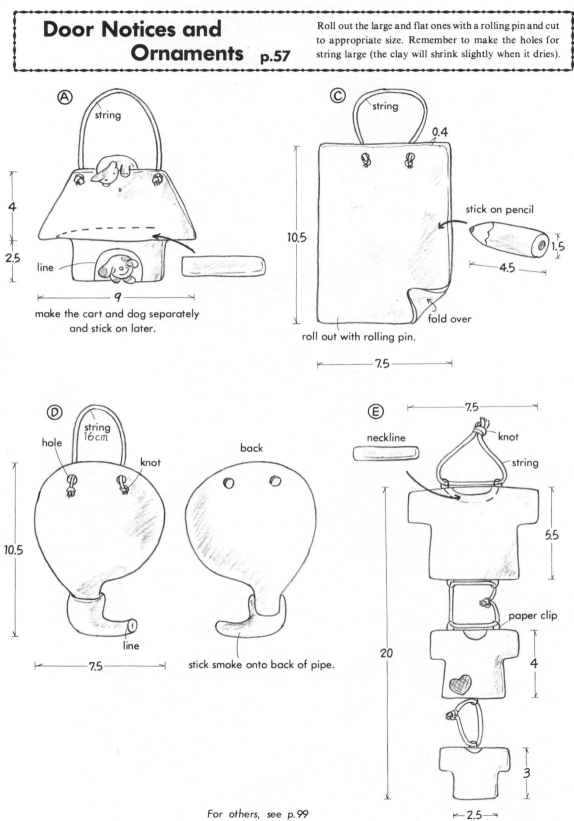

Door Notices and Ornaments p.57

Roll out the large and flat ones with a rolling pin and cut to appropriate size. Remember to make the holes for string large (the clay will shrink slightly when it dries).

Ⓐ string

4

2.5

line

9

make the cart and dog separately and stick on later.

Ⓒ string

0.4

10.5

stick on pencil

1.5

4.5

fold over

roll out with rolling pin.

7.5

Ⓓ string 16cm

hole

knot

back

10.5

7.5

line

stick smoke onto back of pipe.

Ⓔ 7.5

neckline

knot

string

5.5

paper clip

20

4

3

2.5

For others, see p.99

DOLL BROOCHES

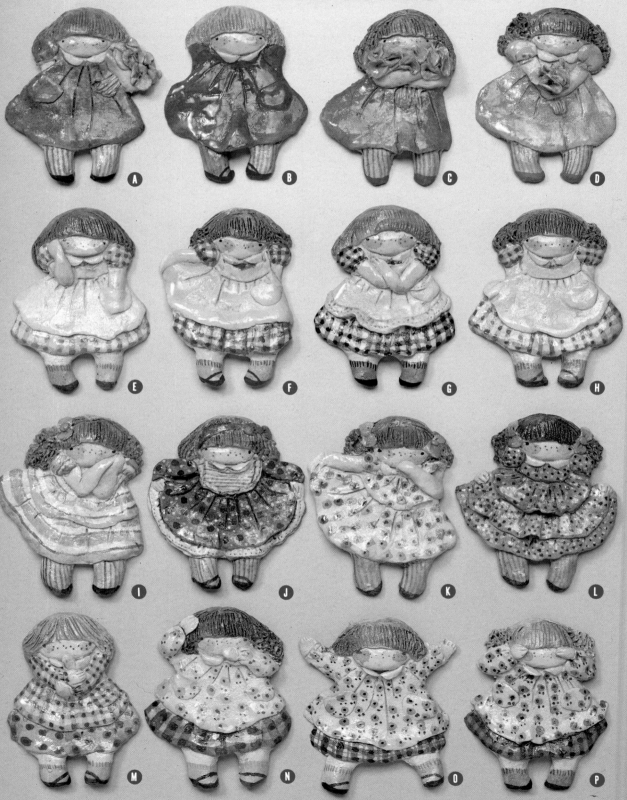

• See p.62/63 for details on how to make these.

★ Actual size

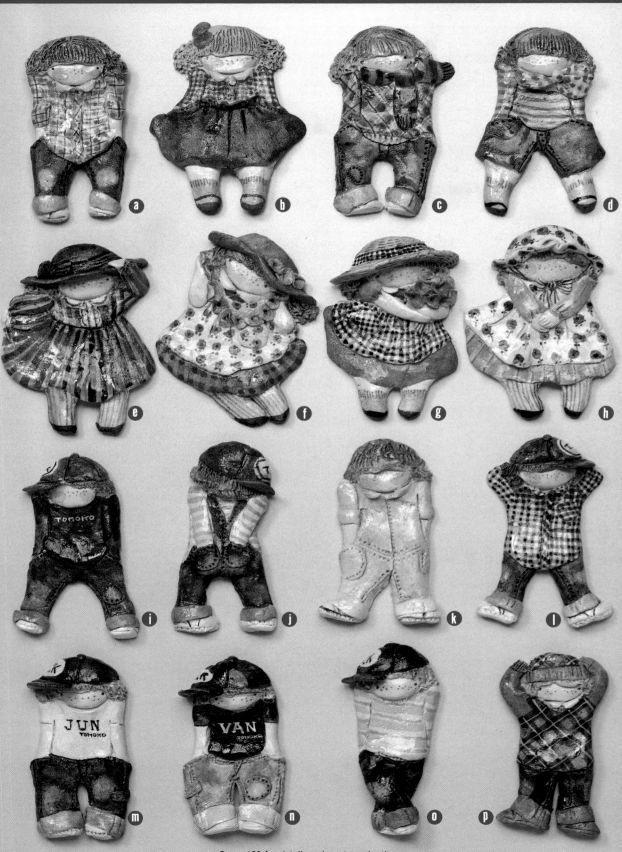

a b c d

e f g h

i j k l

m n o p

★ Actual size ● See p.100 for details on how to make these.

Doll Brooches p.60

The clay tends to stick to your hand and makes it difficult to manage. Use a stainless steel spatula with a small head and it will be much easier to get a good finish.

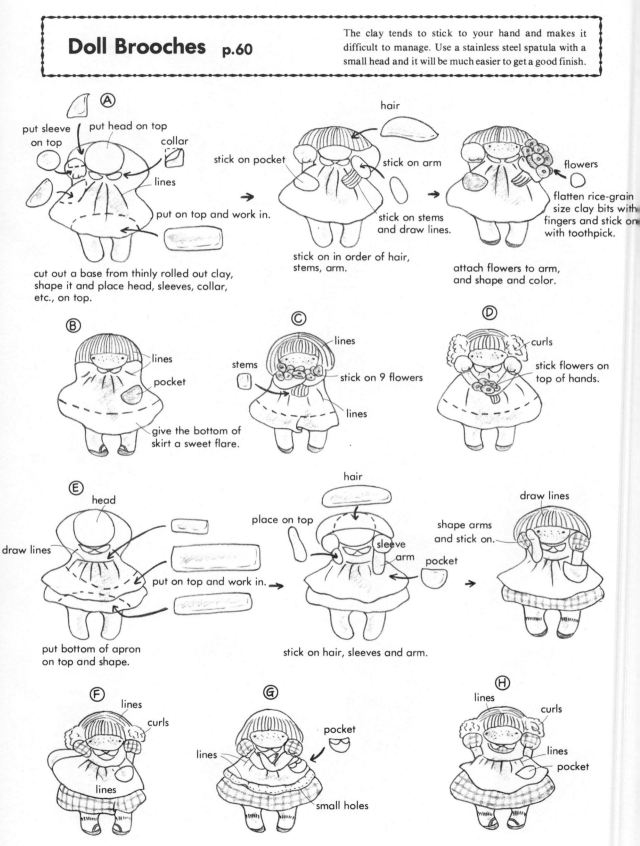

A

put sleeve on top

put head on top

collar

lines

put on top and work in.

cut out a base from thinly rolled out clay, shape it and place head, sleeves, collar, etc., on top.

hair

stick on pocket

stick on arm

stick on stems and draw lines.

stick on in order of hair, stems, arm.

flowers

flatten rice-grain size clay bits with fingers and stick on with toothpick.

attach flowers to arm, and shape and color.

B

lines

pocket

give the bottom of skirt a sweet flare.

C

lines

stems

stick on 9 flowers

lines

D

curls

stick flowers on top of hands.

E

head

draw lines

put on top and work in.

put bottom of apron on top and shape.

hair

place on top

sleeve

arm

pocket

stick on hair, sleeves and arm.

draw lines

shape arms and stick on.

F

lines

curls

lines

G

pocket

lines

small holes

H

lines

curls

lines

pocket

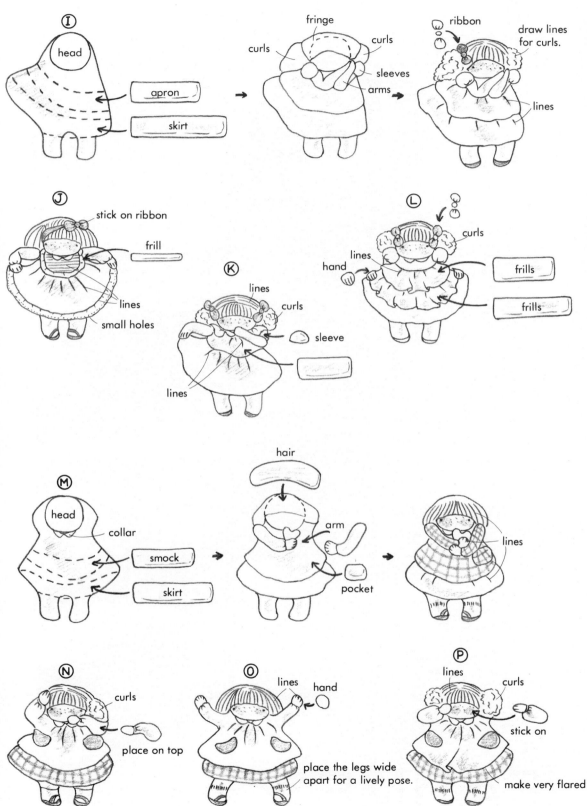

I

head

apron

skirt

fringe
curls
curls
sleeves
arms

ribbon
draw lines
for curls.
lines

J

stick on ribbon

frill

lines

small holes

K

lines
curls
sleeve

lines

L

curls
lines
hand

frills

frills

M

head
collar

smock

skirt

hair

arm

pocket

lines

N

curls

place on top

O

lines
hand

place the legs wide
apart for a lively pose.

P

lines
curls

stick on

make very flared

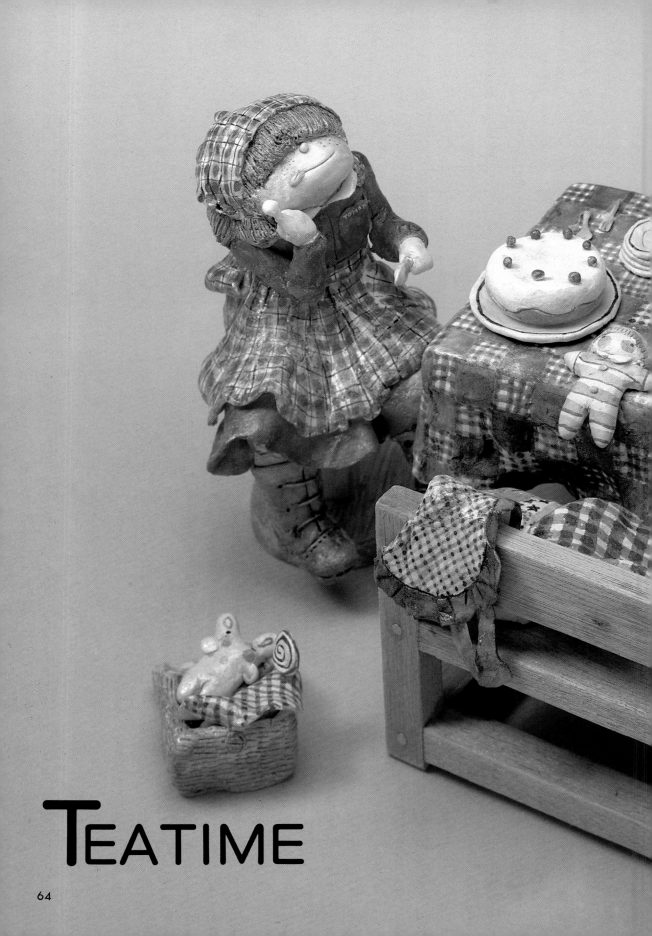

TEATIME

• See p.101 for details on how to make these.

INDOORS ON A RAINY DAY

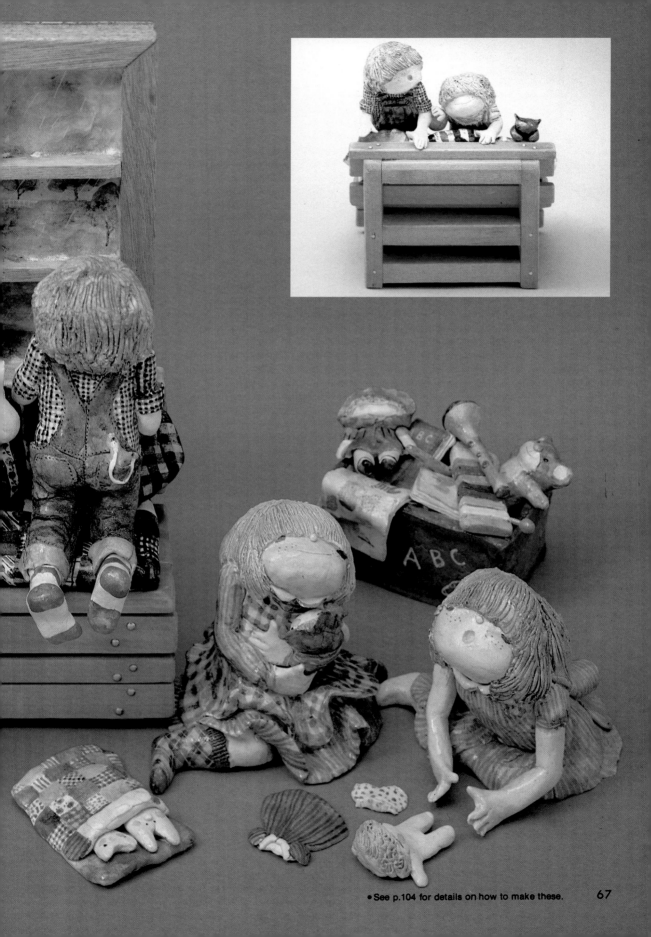

• See p.104 for details on how to make these. 67

NURSERY IN THE CLOUDS

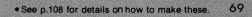

• See p.108 for details on how to make these. 69

FRAMED PICTURES

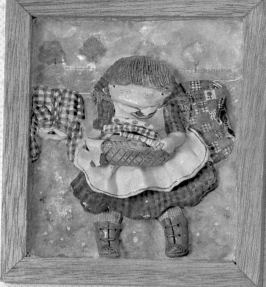

"Washing day"
● See p.112 for details
on how to make this.

Spread the clay onto the backing of the frame and place the hands and dresses on top. For the beginner, starting with the frame means less risk of failure. The process is explained in detail with photographs for "The stew is ready" (p.74). Refer to it and enjoy making original designs such as one showing your own room.

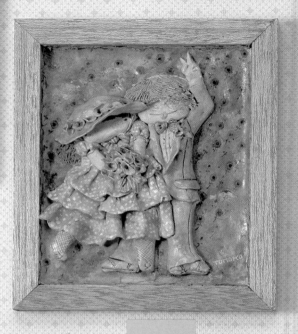

"V-sign.'I've won her over!'"
● See p.112 for details
on how to make this.

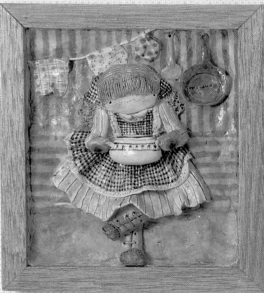

"The stew is ready."
● See p.74 for details
on how to make this.

Illustrated on "Let's Make..." pages.

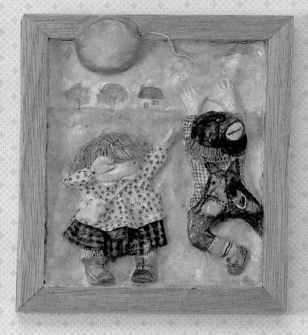

"I'll get it for you."
●See p.113 for details
on how to make this.

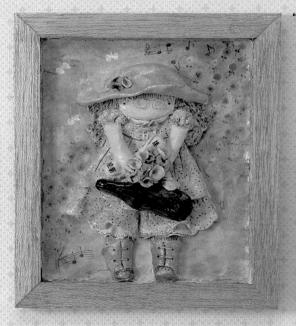

"Playing on concert day."
●See p.113 for details
on how to make this.

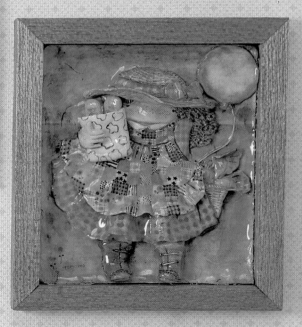

**"I went on an errand and
was given a balloon."**
●See p.114 for details
on how to make this.

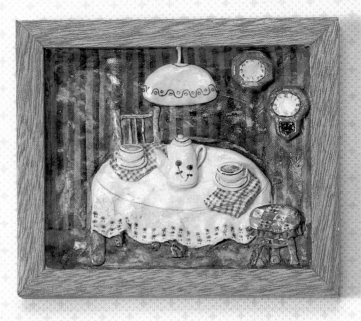

"The tea is ready."
•See p.114 for details
on how to make this.

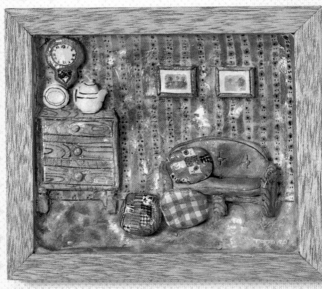

"I wonder who's coming……"
•See p.115 for details
on how to make this.

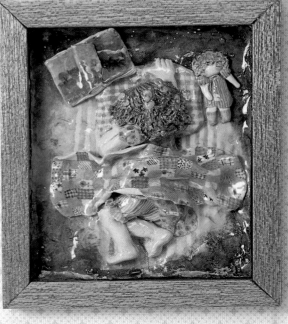

"In the land of dreams"
•See p.115 for details
on how to make this.

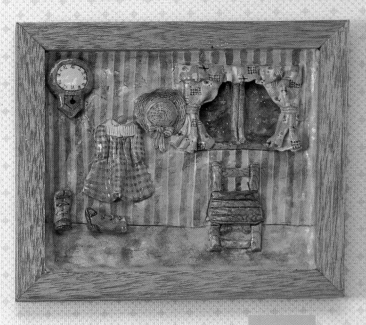

"My room"
●See p.116 for details
 on how to make this.

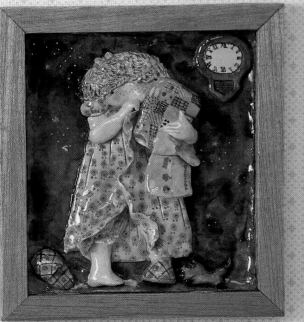

"Goodnight"
●See p.116 for details
 on how to make this.

LET'S MAKE A FRAMED PICTURE

"The Stew is ready" on p.70.

How to make: The surface of the clay tends to get dry. Keep the surface soft by constantly putting water on your work so that you can make any corrections later. The water is also used to stick on clay. Clay will shrink by 10–20% when it dries and a gap will appear between the clay and the frame. Fill this up after the clay has dried completely.

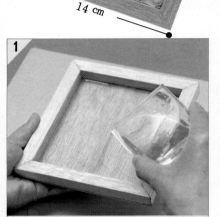

16 cm

14 cm

What to Use

approx. ²/₃ packet of modelling clay (500g packet)

palette

water

work base

frame

water colors

lacquer

towel

spatula toothpick

brushes

1

Refer to p.111 and make a frame. Pour in water, moisten back of frame and throw away water.

2

Press clay to a thickness of 0.5cm taking care not to leave any gaps.

3

Make outline of body and stick onto base with water.

4

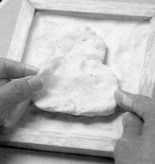

Make face and fringe and place on base. Put water on fingers and smooth over face surface and chin. Next put on collar.

Collar

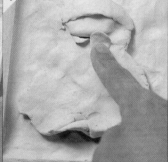

5

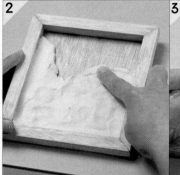

Stick on clay for neckline and frills down front of apron. Work in.

6

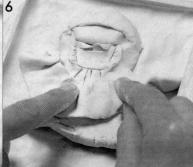

For the bottom part of the apron, roll clay out flat and stick on so that it has gathers and is raised.

7

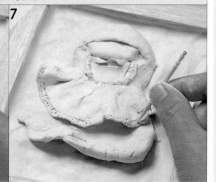

Use toothpick to draw lines for the border and make holes for the lace pattern.

8

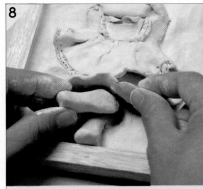

Raise the hem of the skirt to put in legs. Make the base of the legs flat.

9

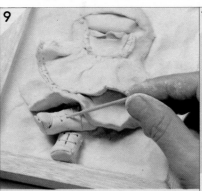

Put in lines for shoes and stick on clay rolled thin for the string. Make holes for laces.

10 Arm

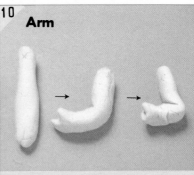

Roll the clay into a cylindrical shape, bend and shape fingers at end. Put a little clay around the wrist to give the impression of oven gloves.

11

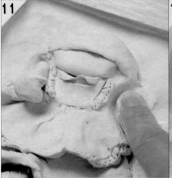

Press the base of the arms with a finger and stick the arms on top.

12

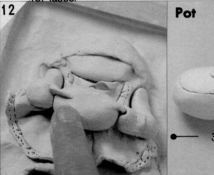

Place the pot on top of the stomach, arrange the arms to suggest she is holding it and stick on the handles.

Pot

3

13

Use spatula to draw lines for scarf, curls and hair.

14

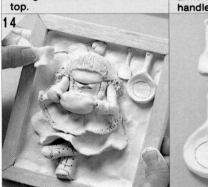

Make the utensils to balance with the size of the doll. Make them one at a time, moisten and place wherever you wish.

Fish slice

Frying pan

15

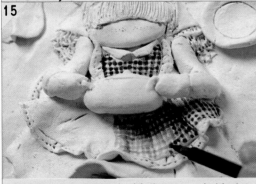

Once it has completely dried, use a pale black to paint the horizontal and vertical lines, wait till this is dry and paint a circle where all the lines cross.

16 Coloring

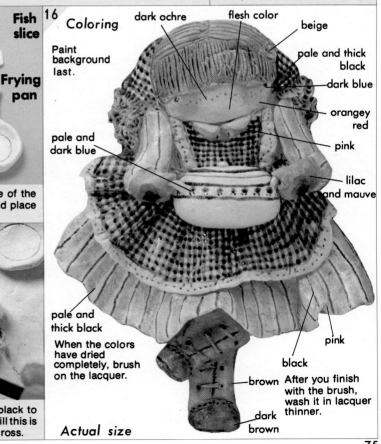

Paint background last.

dark ochre

flesh color

beige

pale and thick black

dark blue

orangey red

pink

lilac and mauve

pale and dark blue

pale and thick black

When the colors have dried completely, brush on the lacquer.

pink

black

brown

dark brown

After you finish with the brush, wash it in lacquer thinner.

Actual size

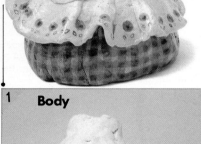

"Beth" on p.28

LET'S MAKE
A STANDING DOLL

12 cm

What to Use: Approx. 1 packet of modelling clay (500g packet), 1 stick.
For others, see the framed picture on p.74.

1 Body 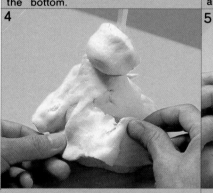 Use approx. ⅓ of the clay to make the body and leave about 5cm hollow at the bottom.	**2 Face** 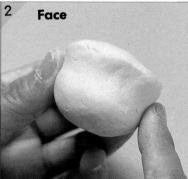 Roll clay about the size of a table tennis ball to make the face and indent the eye area.	**3** 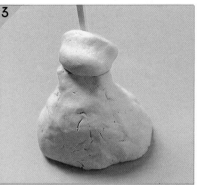 Place the face on the body, work the neck into the body and place a stick through the centre.
4 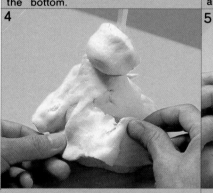 Thinly roll out a piece of clay 3cm wide and stick on, arranging gathers.	**5** 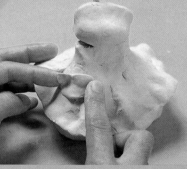 Smooth down the waist and stick on a pocket, thinly flattened and shaped.	**6** 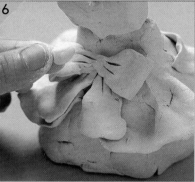 Make each part of the ribbon separately and stick onto the back of the apron.
7 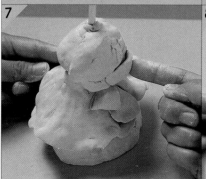 Tear off small pieces of clay, moisten and shape the round outline of the head and the back of the hair.	**8** 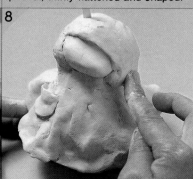 Stick on the fringe and the hair at the sides, moisten finger tips and smooth the surface.	**9** 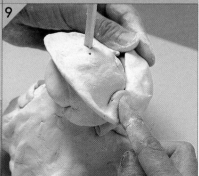 Roll out clay to a width of 2cm, place around head and make the brim of the bonnet.

10

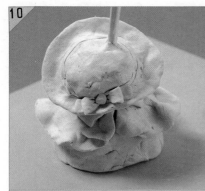

Put more clay on top of the head and shape round part of the hat. Draw lines for ribbon and stick on the bow.

11

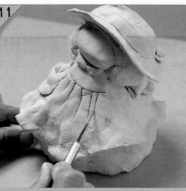

Put on collar and draw lines for gathered effect of apron with spatula.

12 Arms

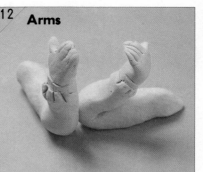

Make arms, put a little clay around the cuffs to give puffed out effect and use spatula to draw lines and shape fingers.

13

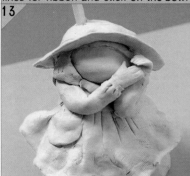

Indent the base of the arms on the body, moisten, stick on arms and shape for the right pose.

14

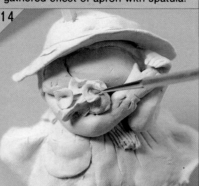

Place the base for the flowers on top of the arm, the stems below the arm and the flowers on the base.

15

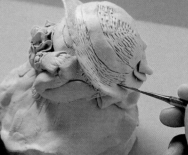

Remove the stick and fill in the hole. Draw lines for the bonnet, the hair and the mouth.

16

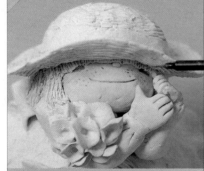

Once it has dried completely, color the face in a flesh color and follow this in the order of blusher, freckles and eyes.

17

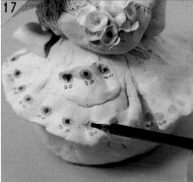

Draw the flowers on the border of the apron and on the pocket, putting a dark color in the centre later.

18 Coloring

Start with the pale colors and paint on top when the paint is dry.

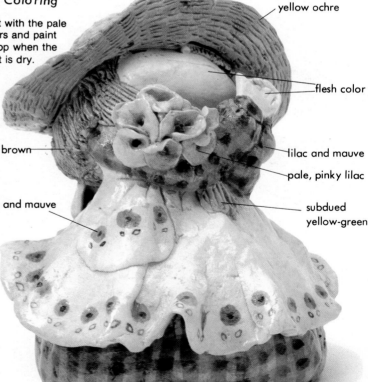

yellow ochre

flesh color

pale brown

lilac and mauve

pale, pinky lilac

lilac and mauve

subdued yellow-green

Actual size

LET'S MAKE A PAIR OF WALL ORNAMENTS (GIRL)

What to Use: Approx. 1 packet of modelling clay (500g packet) for the pair, 2 paper clips, adhesive, piece of thin wire. For other, see the framed picture on p.74.

How to Make: Trace the photograph given below and make a pattern.

Coloring: Refer to the photograph below.

The color will come up more vividly when the lacquer is put on, so use slightly paler colors than in the photograph. It looks attractive if you use different tones of the same color every other rectangle and then put patterns in the remaining ones. For the frying pan, color it first and then stick it to the hand with adhesive.

Pattern and Coloring

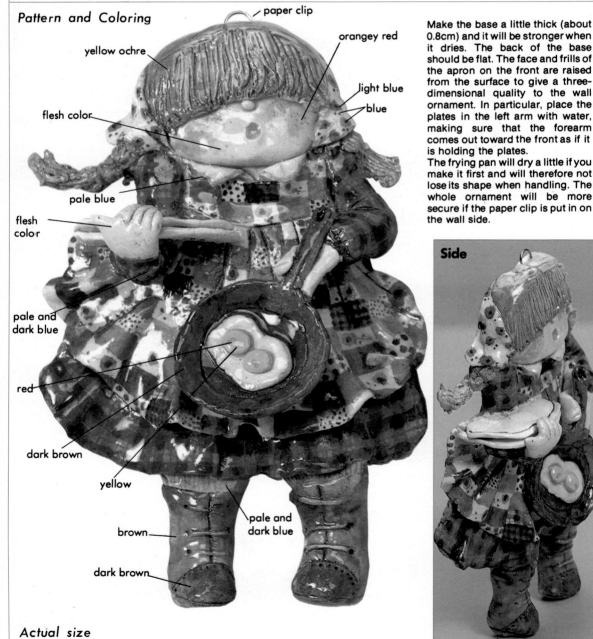

paper clip

orangey red

yellow ochre

light blue

blue

flesh color

pale blue

flesh color

pale and dark blue

red

dark brown

yellow

brown

dark brown

pale and dark blue

Actual size

Make the base a little thick (about 0.8cm) and it will be stronger when it dries. The back of the base should be flat. The face and frills of the apron on the front are raised from the surface to give a three-dimensional quality to the wall ornament. In particular, place the plates in the left arm with water, making sure that the forearm comes out toward the front as if it is holding the plates.

The frying pan will dry a little if you make it first and will therefore not lose its shape when handling. The whole ornament will be more secure if the paper clip is put in on the wall side.

Side

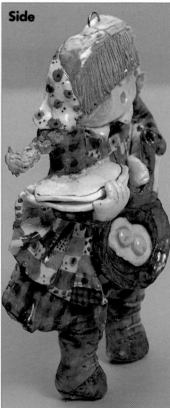

1

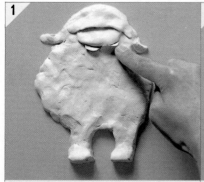

Place the pattern on the rolled out clay, shape the outline and stick on the face, fringe and collar.

2

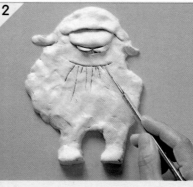

Add a little clay under the collar and raise. Draw lines around the waist.

3

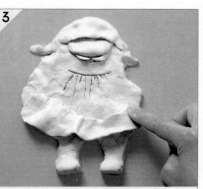

Flatten a piece of clay and stick on around legs, raising it and taking tucks to make gathers for the skirt.

4

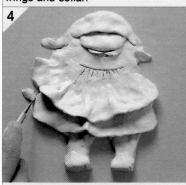

Make the bottom of the apron in the same way as the skirt and discard any unnecessary clay.

5

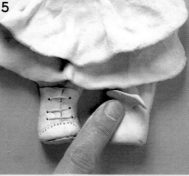

Put some clay on the boundary between the legs and the boots, draw the lines and stick on the strings to finish.

6

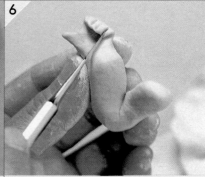

Roll clay into a cylindrical shape, bend, shape into arms and draw lines for fingers.

7

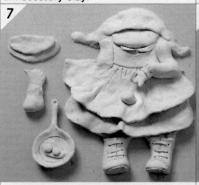

Stick arm onto body and then support for frying pan onto apron.

8

Stick plates onto right arm and place forearm underneath. Put frying pan into left hand.

9

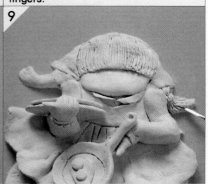

Draw lines for scarf, then draw lines for fringe and braids.

10

paper clip

piece of wire

Pass pieces of thin wire through braids to strengthen and stick paper clip into head.

11

Stick on nose. Then put water onto end of wooden skewer and make mouth, twisting a little as you push.

12

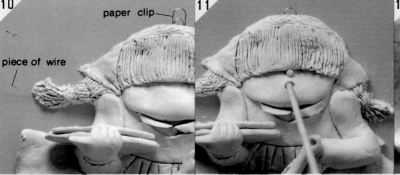

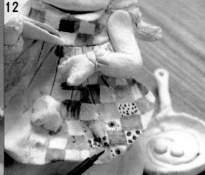

Once it has dried, remove frying pan and color. Take care with the pattern of the frock, scarf, etc.

LET'S MAKE A PAIR OF WALL ORNAMENTS (BOY)

What to Use: See p.78

How to Make: Shape the outline of the body and put on pieces of clay in the order of face, hair, head, crown and brim of cap. Make bib and shoulder straps of the dungarees by referring to the pictures on the right. Finish off the pocket, rolled up trousers and shoes.

Pattern and Coloring

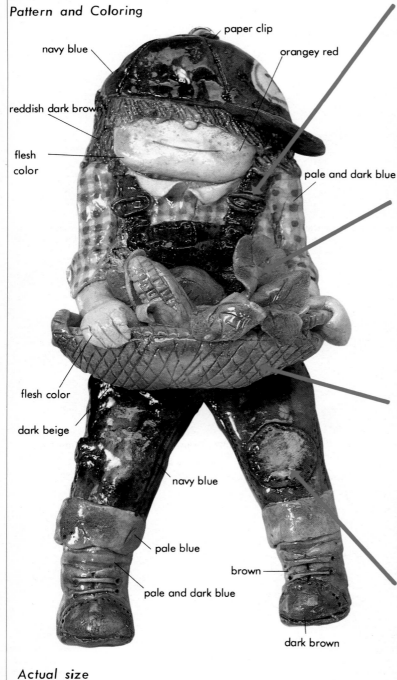

paper clip

navy blue

orangey red

reddish dark brown

flesh color

pale and dark blue

flesh color

dark beige

navy blue

pale blue

brown

pale and dark blue

dark brown

Actual size

Bib and Shoulder Straps

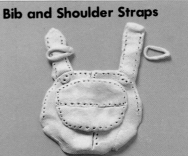

Thinly roll out the clay, make bib, pocket and shoulder straps and put on boy's chest.

Vegetables

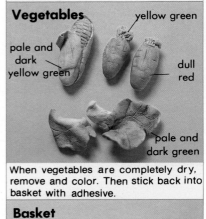

yellow green

pale and dark yellow green

dull red

pale and dark green

When vegetables are completely dry, remove and color. Then stick back into basket with adhesive.

Basket

Roll clay into cylindrical shape, make basket and stick onto boy's stomach.

Rub with moistened brush to remove some of color from knees to give faded blue denim effect.

What to Use

Modelling Clay

Put a little water in the palm of your hands and knead the clay well until it is about the texture of an earlobe. You can also use it without so much kneading. Its material qualities will give it a different, natural appeal. Try to take only the necessary amount out of the packet and if you have any left over, keep it in a plastic bag or something similar. If you have to stop before you finish, keep your work from drying out by spraying it all over with water and either putting it inside a plastic bag or wrapping it in plastic wrap.

Coloring, Brushes

Water colors are used for coloring. The desired colors are applied in the same way as in painting. The finished work will look much more attractive if you wait until each color is completely dry before applying another color on top. Have about 3 brushes ready—a thin one for painting fine detail like facial expressions, a medium one for painting clothes, etc., and a thick one for painting large areas. Use them according to what you are coloring.

Rolling Pin

Used when rolling the clay out so that it is very thin, or of an even thickness.

Spatula

Used when cutting the clay or drawing lines. It is also used quite often to work hair and clothes.

Wooden Skewer

Used for the same sort of things as the spatula. It is convenient in that it is easily obtainable. But since it soaks up a lot of water, the tip ends up soft and swollen, and you will find it necessary to change skewers quite often.

Toothpick

Used for instance as the centre support of the head. Also very useful for putting in stitching marks.

Stick (About 9 in. or 23 cm.)

Used as the centre support of the body of standing dolls.

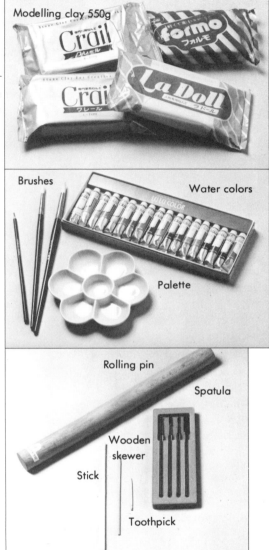

Modelling clay 550g · Crail · formo · La Doll

Brushes · Water colors · Palette

Rolling pin · Spatula · Wooden skewer · Stick · Toothpick

SPECIAL NOTE

Before You Start

Clay modelling is the same as drawing on paper. It is a way to create the desired doll or article in three-dimensional form using clay. There is no "correct" or "incorrect" way and the secret of producing something attractive lies in enjoying the process of making it.

How to Dry and for How Long

Clay shrinks by 10-20% when it dries, and this should be taken into account when working. Care must be taken, especially when making such articles as a door notice or ornament, to insure that the hole is sufficiently larger than the thickness of the cord that is to be threaded through. The finished work should be placed on a wooden board (those that have flat bases, such as wall ornaments and small articles) and left in a well-ventilated room. If you wish to dry it quickly, you can leave it in direct sunlight. It is ready when both the underside and inside are white. The time it takes to dry differs according to the season and the weather, but framed pictures and wall ornaments take approximately 2 - 3 days, standing dolls take approximately 1 week and small articles take approximately 1 day. In the case of standing dolls, if you wait for it to dry a little and then scoop out clay from the middle of the body, it will dry more quickly. The clay thus left over may be used for making small articles such as brooches and earrings.

Glazing

Lacquer is used. Glazing will prevent fading and discoloration as well as reinforce the clay. Soak your brush with the lacquer and apply lightly to the clay. When it dries, put on another layer and then repeat. Two or three layers will insure a luster finish and the colors will seem clearer. When you want to give the feel of warmth, you should not use lacquer, but leave it just painted. The brush for lacquering should be washed in lacquer thinner and kept so that you can use it anytime.

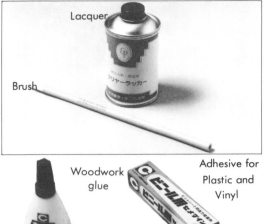
Lacquer
Brush

Woodwork Glue, Adhesive for Plastic and Vinyl

Work Base

A celluloid or acrylic board is used as an underlay. Using this work base will enable you to turn the board and see your work from various angles or, when you have to stop before you finish, to move the board together with your work to another place without damaging it.

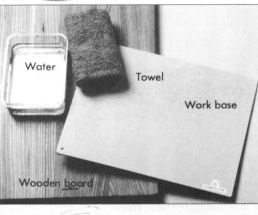
Woodwork glue
Adhesive for Plastic and Vinyl
Water
Towel
Work base
Wooden board

Water

Use in kneading the clay until it is soft and in smoothing the surface. It is also used as an adhesive in sticking clay together and it is vital in clay modelling.

Towel

In order to insure that your hand is always clean when you are modelling in clay, you should constantly wipe your hands clean a on wet towel.

Wooden Board

(Flat piece of wood, unused chopping board, etc.) Can be used as a work base and as a board for drying wall ornaments. The wood will soak up just the right amount of water to insure the work dries without warping.

Wire, Paper Clips, Brooch Pins, Earring Bases

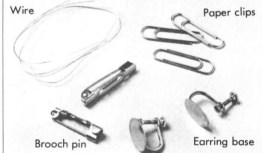
Wire
Paper clips
Brooch pin
Earring base

SPECIAL NOTE

Before Coloring

Apply colors directly onto work after drying. Since colors come up brighter when lacquer is applied make the color a little paler than the finished tint you have in mind. Try to start with the lighter colors, for instance, try to color the face and hands first. Then color the clothes—the part that is the most important point of the work—and do the other colors accordingly. Also, be careful in choosing the color for the hair as it is an important colour that can enhance or spoil the look of the face.

When you want to make the face a white and translucent one, for instance, apply a coating of a dark color such as dark brown, followed by a coat of a pale color such as beige. You will end up with a soft and gentle finish.
SELECT THE COLORS ACCORDING THE
MOOD OF THE WHOLE. Lastly, draw in the expressions of the face. If you make a mistake, scrape off that bit with your spatula, then dust off all the flakes with a dry brush and apply color again.

Framed Ornaments, Chairs and Tables

Veneer boards and lauan are used to make such props as chairs and tables. You should make these first and then go on to the figures, arranging their poses to fit the props. If you are not good at using saws and nails, you can always use children's toys or bricks and arrange your figures on these instead.

Wall Ornaments p.5

For what to use, see p.2

In order to make them look more like jeans, moisten the tip of a brush and rub to take some of the color away. It will give the impression of faded denim.

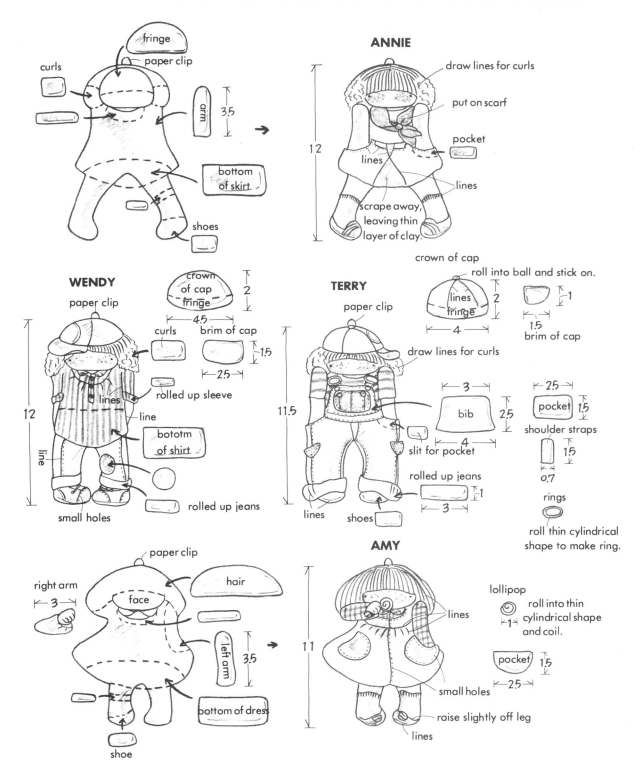

fringe
paper clip
curls
arm
3.5
bottom of skirt
shoes

ANNIE
draw lines for curls
put on scarf
pocket
12
lines
lines
scrape away, leaving thin layer of clay.

WENDY
paper clip
crown of cap
fringe
2
4.5
curls
brim of cap
1.5
2.5
rolled up sleeve
lines
line
bototm of shirt
12
line
rolled up jeans
small holes

TERRY
paper clip
crown of cap
roll into ball and stick on.
lines
fringe
2
1
4
1.5
brim of cap
draw lines for curls
11.5
3
bib
2.5
4
slit for pocket
2.5
pocket
1.5
shoulder straps
1.5
0.7
rolled up jeans
1
3
lines
shoes
rings
roll thin cylindrical shape to make ring.

paper clip
hair
right arm
3
face
left arm
3.5
bottom of dress
shoe

AMY
lollipop
roll into thin cylindrical shape and coil.
1
lines
11
pocket
1.5
2.5
small holes
raise slightly off leg
lines

83

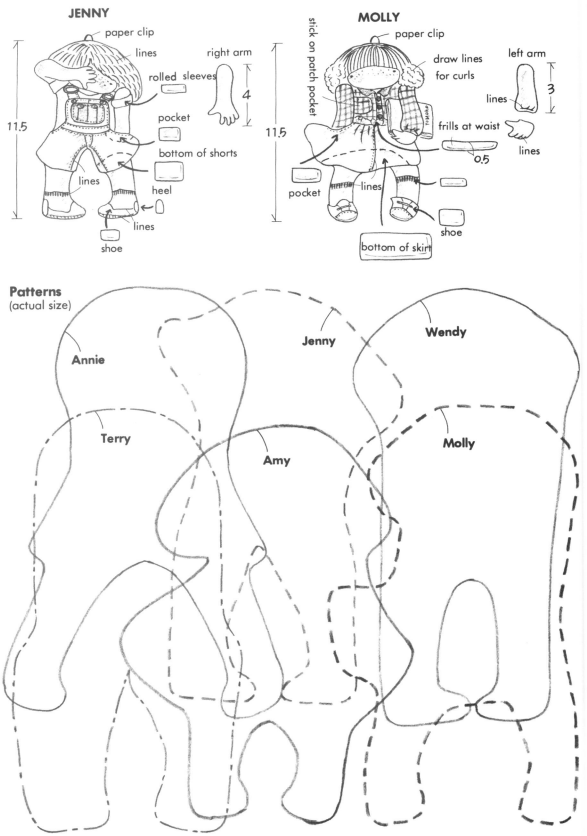

JENNY

paper clip

lines

right arm

rolled sleeves

4

pocket

bottom of shorts

11.5

heel

lines

lines

shoe

MOLLY

stick on patch pocket

paper clip

draw lines for curls

left arm

lines

3

frills at waist

0.5

lines

11.5

pocket

lines

shoe

bottom of skirt

Patterns
(actual size)

Annie

Jenny

Wendy

Terry

Amy

Molly

Wall Ornaments p.9

For what to use, see p.2

For the sunflowers, make slightly large round and flat centers for the flowers, place these on the arm and position the petals attractively around them. Draw lines across the center of the sunflower with a spatula.

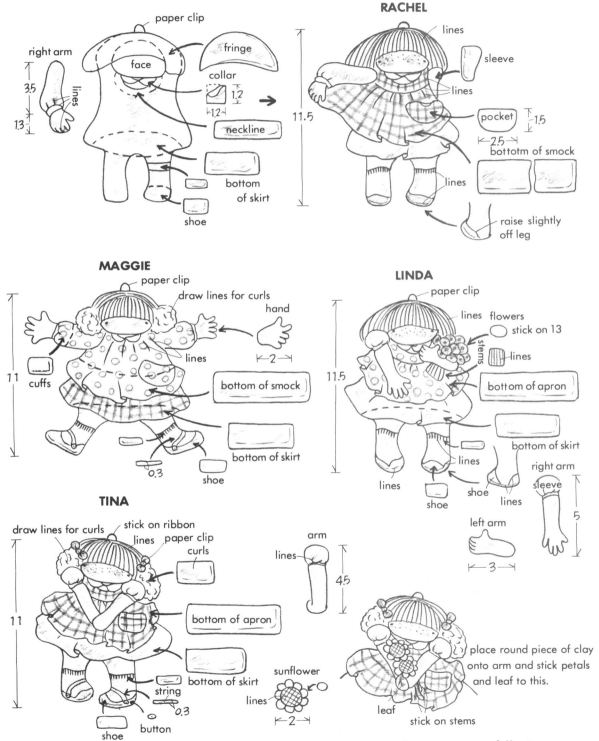

paper clip

fringe

face

collar

1.2

1.2

right arm

3.5

1.3

lines

neckline

bottom of skirt

shoe

RACHEL

lines

sleeve

lines

11.5

pocket

1.5

2.5

bottotm of smock

lines

raise slightly off leg

MAGGIE

paper clip

draw lines for curls

hand

lines

2

11

cuffs

bottom of smock

0.3

shoe

bottom of skirt

LINDA

paper clip

lines flowers

stick on 13

stems

lines

11.5

bottom of apron

bottom of skirt

right arm

sleeve

lines

lines

shoe

lines

left arm

5

3

TINA

draw lines for curls

stick on ribbon

lines

paper clip

curls

lines

11

arm

lines

4.5

bottom of apron

bottom of skirt

string

0.3

shoe

button

sunflower

lines

2

place round piece of clay onto arm and stick petals and leaf to this.

leaf

stick on stems

For patterns, see following page.

Patterns
(actual size)

Maggie

Tina

Rachel

Linda

Pigs' Wedding p.13

For what to use, see p.14

In order to give the bride a fresh, naive look, use a pale pink color and in order to give the bridegroom an embarrassed, self-conscious look, put an extra bit of color into his cheeks.

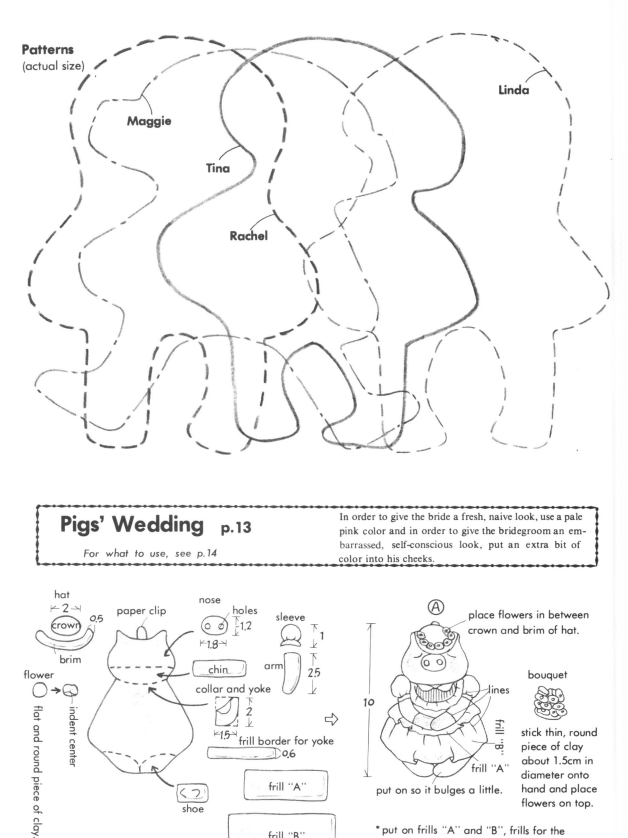

hat
←2→
crown 0.5
brim

flower
○ → ◎
indent center

flat and round piece of clay.

paper clip

nose
○○ holes ↕1.2
←1.8→

chin

collar and yoke

2

←1.5→
frill border for yoke
▷0.6

frill "A"

frill "B"

shoe

sleeve
↕1

arm ↕2.5

⇨

10

Ⓐ

place flowers in between crown and brim of hat.

bouquet

lines

frill "B"

frill "A"

put on so it bulges a little.

stick thin, round piece of clay about 1.5cm in diameter onto hand and place flowers on top.

* put on frills "A" and "B", frills for the yoke, taking tucks in order to make gathers.

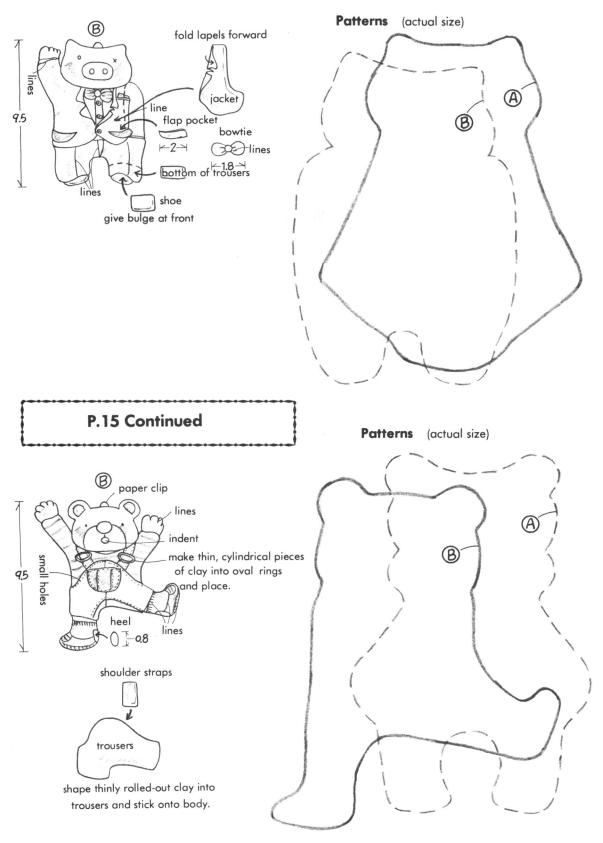

Ⓑ

fold lapels forward

9.5 lines

jacket

line
flap pocket

bowtie
lines

← 2 →

bottom of trousers

← 1.8 →

lines

shoe
give bulge at front

Patterns (actual size)

Ⓑ

Ⓐ

P.15 Continued

Ⓑ paper clip

lines

indent

make thin, cylindrical pieces
of clay into oval rings
and place.

9.5 small holes

heel

lines

0.8

shoulder straps

trousers

shape thinly rolled-out clay into
trousers and stick onto body.

Patterns (actual size)

Ⓐ

Ⓑ

The Sporty Hippo Family
p.25

For the fat mother, give a rounded effect by sticking on extra pieces of clay. For her breasts, make two round pieces and give her a big bust.

What to Use

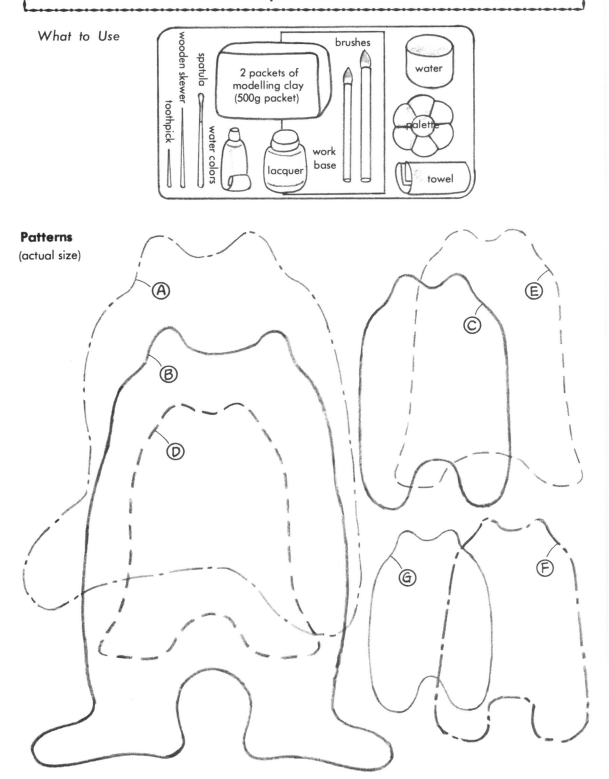

2 packets of modelling clay (500g packet)

wooden skewer

spatula

toothpick

water colors

brushes

water

palette

lacquer

work base

towel

Patterns

(actual size)

A

B

C

D

E

F

G

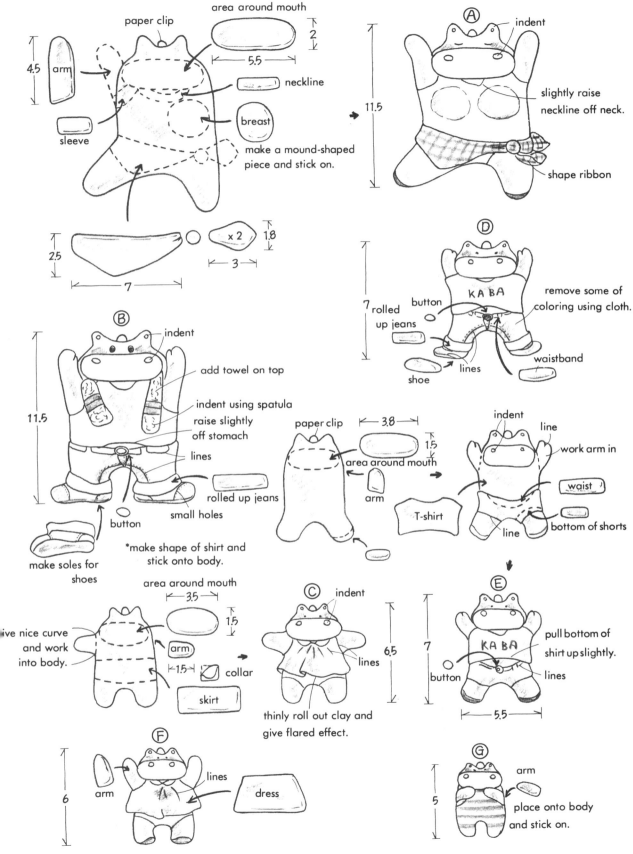

paper clip

area around mouth

2

5.5

neckline

breast

make a mound-shaped
piece and stick on.

arm

4.5

sleeve

Ⓐ indent

11.5

slightly raise
neckline off neck.

shape ribbon

2.5

7

x 2

1.8

3

Ⓓ

7 rolled
up jeans

button

KABA

remove some of
coloring using cloth.

lines

shoe

waistband

Ⓑ indent

add towel on top

indent using spatula
raise slightly
off stomach

lines

11.5

rolled up jeans

small holes

button

make soles for
shoes

*make shape of shirt and
stick onto body.

paper clip

3.8

1.5

area around mouth

arm

T-shirt

indent

line

work arm in

waist

bottom of shorts

line

ive nice curve
and work
into body.

area around mouth

3.5

1.5

arm

1.5

collar

skirt

Ⓒ indent

lines

6.5

thinly roll out clay and
give flared effect.

Ⓔ

7

KABA

button

pull bottom of
shirt up slightly.

lines

5.5

Ⓕ

arm

6

lines

dress

Ⓖ

arm

5

place onto body
and stick on.

Kitten Kindergarten p.17

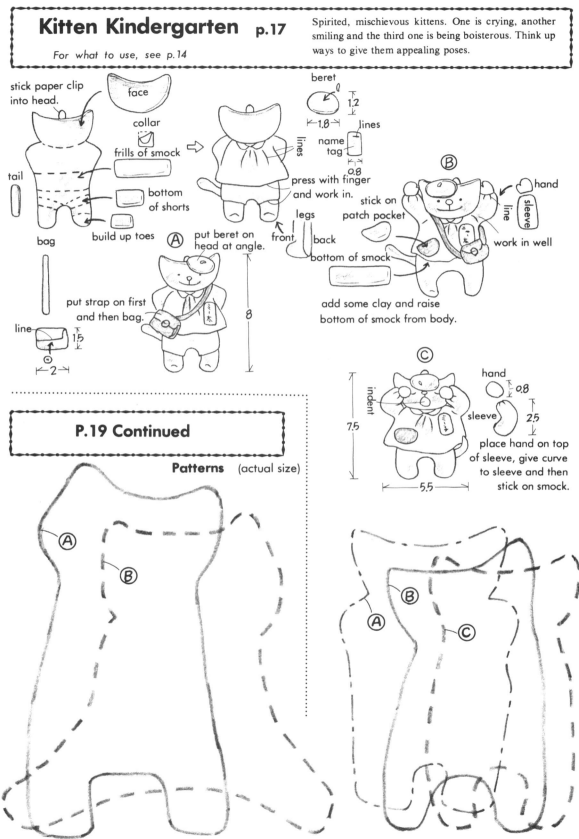

For what to use, see p.14

Spirited, mischievous kittens. One is crying, another smiling and the third one is being boisterous. Think up ways to give them appealing poses.

stick paper clip into head.

face

collar

frills of smock

tail

bottom of shorts

build up toes

bag

put strap on first and then bag.

line

1.5

2

beret

1.2

1.8

lines

name tag

0.8

lines

press with finger and work in.

put beret on head at angle.

legs

front

back

bottom of smock

8

Ⓐ

Ⓑ

hand

sleeve

line

stick on patch pocket

work in well

add some clay and raise bottom of smock from body.

Ⓒ

indent

7.5

5.5

hand

0.8

sleeve

2.5

place hand on top of sleeve, give curve to sleeve and then stick on smock.

P.19 Continued

Patterns (actual size)

Ⓐ

Ⓑ

Ⓐ

Ⓑ

Ⓒ

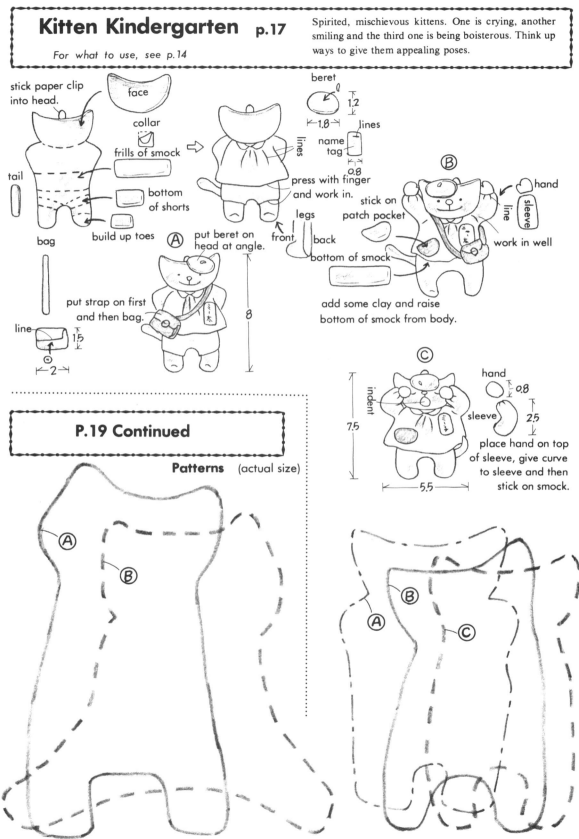

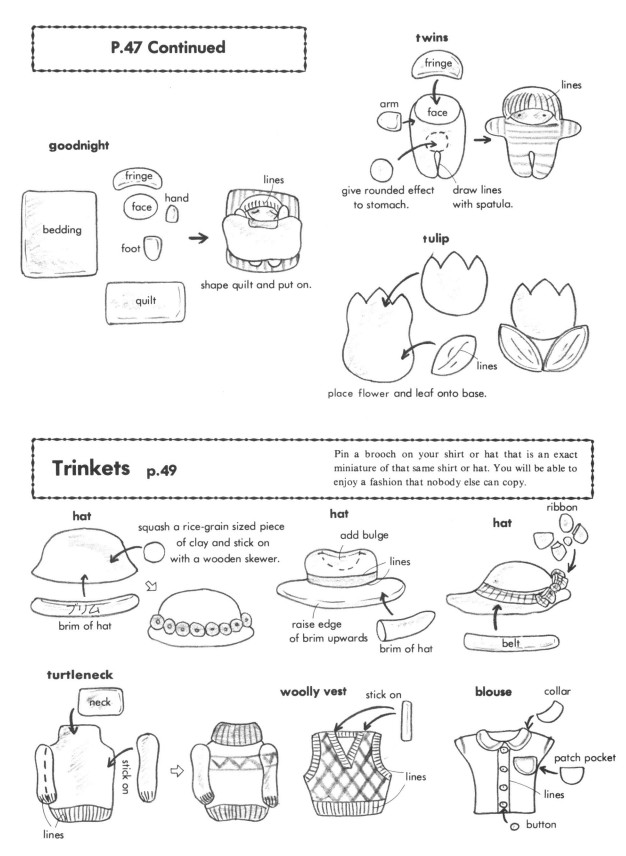

P.47 Continued

twins

fringe

arm

face

lines

give rounded effect to stomach.

draw lines with spatula.

goodnight

bedding

fringe

face

hand

foot

quilt

lines

shape quilt and put on.

tulip

lines

place flower and leaf onto base.

Trinkets p.49

Pin a brooch on your shirt or hat that is an exact miniature of that same shirt or hat. You will be able to enjoy a fashion that nobody else can copy.

hat

squash a rice-grain sized piece of clay and stick on with a wooden skewer.

brim of hat

ブリム

hat

add bulge

lines

raise edge of brim upwards

brim of hat

hat

ribbon

belt

turtleneck

neck

stick on

lines

woolly vest

stick on

lines

blouse

collar

patch pocket

lines

button

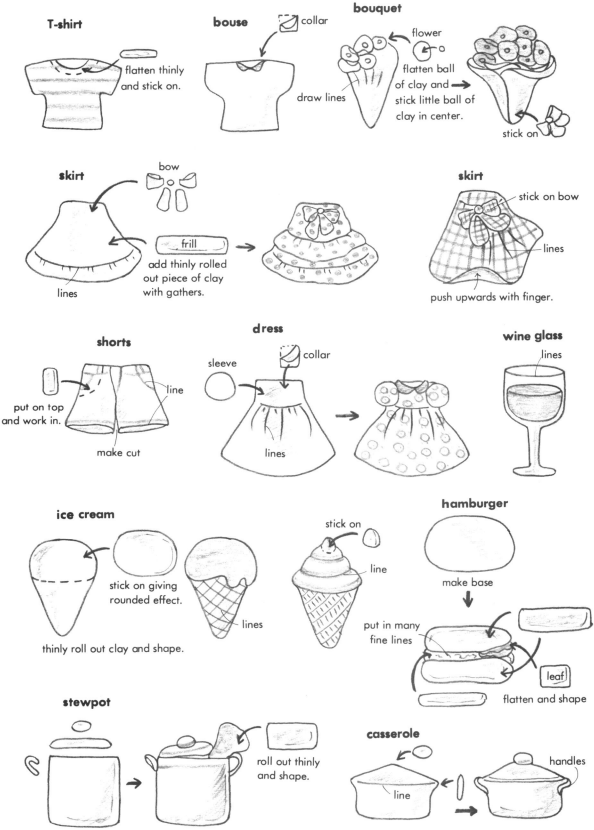

T-shirt
flatten thinly and stick on.

bouse
collar
draw lines

bouquet
flower
flatten ball of clay and stick little ball of clay in center.
stick on

skirt
bow
frill
add thinly rolled out piece of clay with gathers.
lines

skirt
stick on bow
lines
push upwards with finger.

shorts
put on top and work in.
line
make cut

dress
sleeve
collar
lines

wine glass
lines

ice cream
stick on giving rounded effect.
lines
thinly roll out clay and shape.

stick on
line
put in many fine lines

hamburger
make base
leaf
flatten and shape

stewpot
roll out thinly and shape.

casserole
handles
line

92

Wall Ornaments Bottom of p.32

For what to use, see p.34

The coloring for the girl's apron is the same as that shown on p.78. Make sure that you draw each motif carefully.

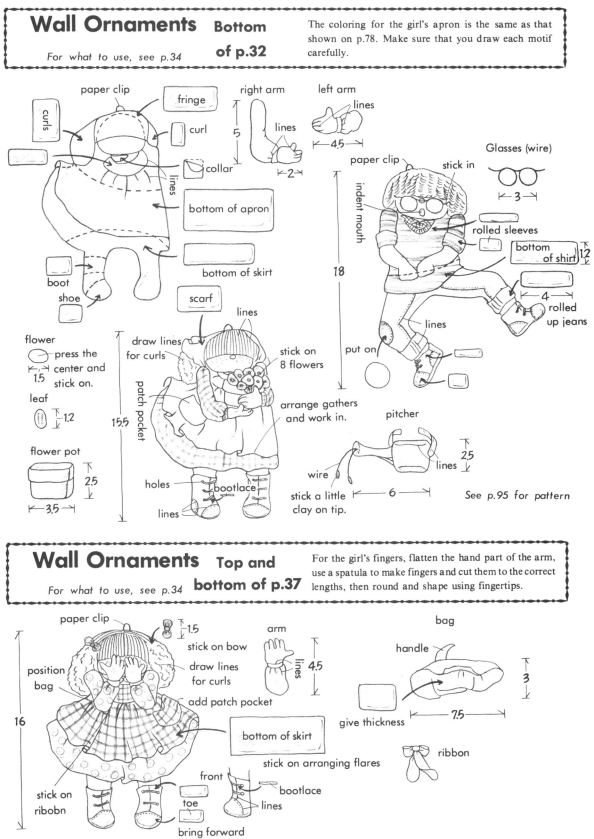

paper clip

curls

fringe

curl

collar

right arm

left arm

lines

lines

5

lines

2

bottom of apron

bottom of skirt

scarf

boot

shoe

flower

press the center and stick on.

1.5

leaf

1.2

flower pot

2.5

3.5

patch pocket

15.5

draw lines for curls

lines

stick on 8 flowers

arrange gathers and work in.

holes

bootlace

lines

paper clip

stick in

indent mouth

Glasses (wire)

3

rolled sleeves

bottom of shirt 1.2

4

rolled up jeans

lines

put on

18

pitcher

wire

stick a little clay on tip.

6

lines

2.5

See p.95 for pattern

Wall Ornaments Top and bottom of p.37

For what to use, see p.34

For the girl's fingers, flatten the hand part of the arm, use a spatula to make fingers and cut them to the correct lengths, then round and shape using fingertips.

paper clip

1.5

stick on bow

draw lines for curls

add patch pocket

position bag

arm

lines 4.5

bag

handle

3

give thickness

7.5

ribbon

16

bottom of skirt

stick on arranging flares

stick on ribobn

front

toe

bootlace

lines

bring forward

93

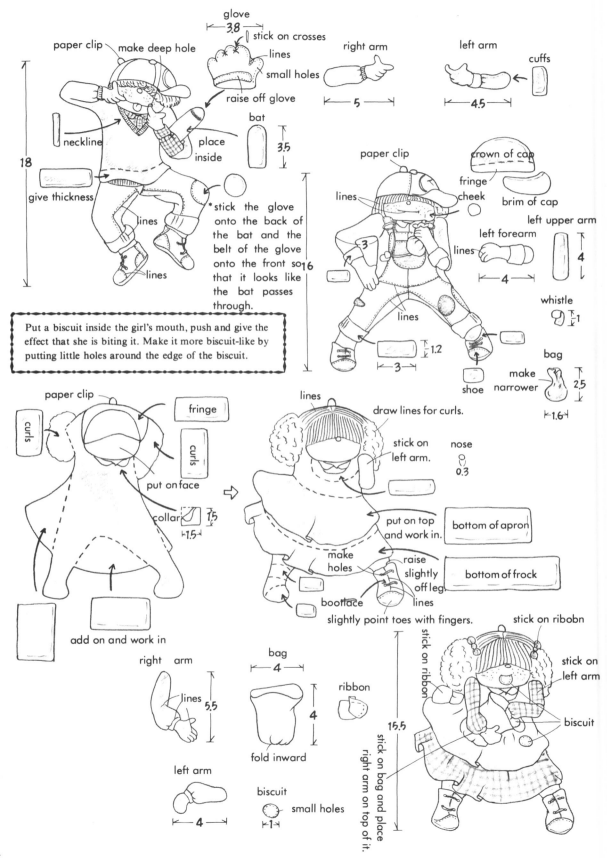

glove
3.8
stick on crosses
lines
small holes
raise off glove

paper clip make deep hole

right arm

left arm
cuffs

5

4.5

neckline

bat
3.5

place inside

18

give thickness

lines

lines

*stick the glove onto the back of the bat and the belt of the glove onto the front so that it looks like the bat passes through.

16

paper clip

crown of cap
fringe
cheek
brim of cap

lines

3

left upper arm
left forearm
lines
4

4

whistle
1

lines

Put a biscuit inside the girl's mouth, push and give the effect that she is biting it. Make it more biscuit-like by putting little holes around the edge of the biscuit.

1.2

3

shoe

bag
make narrower
2.5
1.6

paper clip

fringe

curls

curls

put on face

collar 1.5
1.5

add on and work in

lines

draw lines for curls.

stick on left arm.

nose
0.3

put on top and work in.

bottom of apron

make holes

raise slightly off leg

bootlace lines

bottom of frock

slightly point toes with fingers.

stick on ribobn

right arm

bag
4

ribbon

stick on ribbon

stick on left arm

lines 5.5

4

15.5

biscuit

left arm

fold inward

4

biscuit
small holes
1

stick on bag and place right arm on top of it.

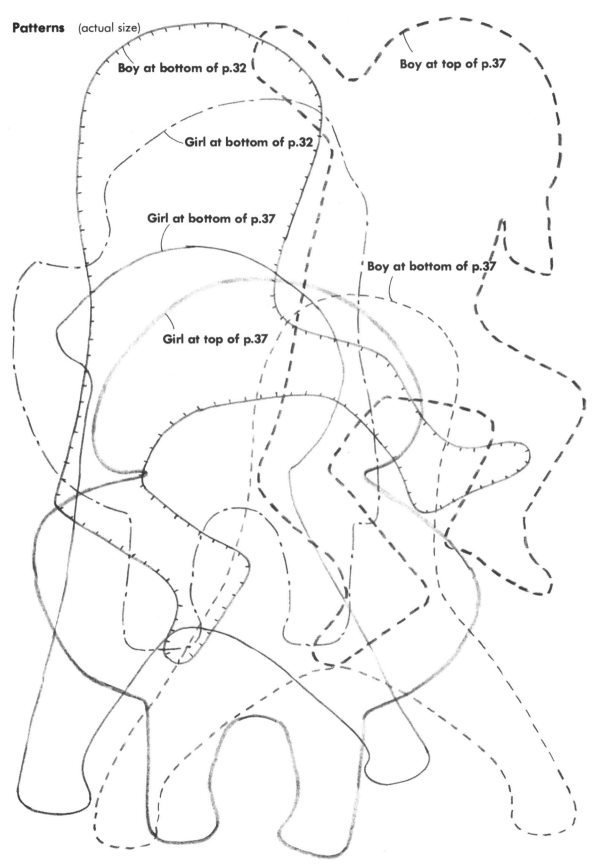

Patterns (actual size)

Boy at bottom of p.32

Boy at top of p.37

Girl at bottom of p.32

Girl at bottom of p.37

Boy at bottom of p.37

Girl at top of p.37

95

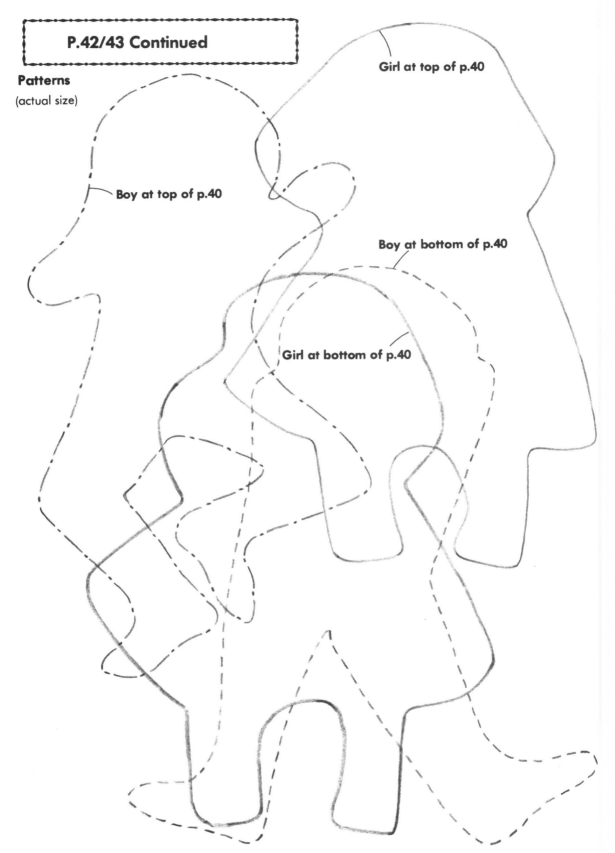

Patterns
(actual size)

Girl at top of p.40

Boy at top of p.40

Boy at bottom of p.40

Girl at bottom of p.40

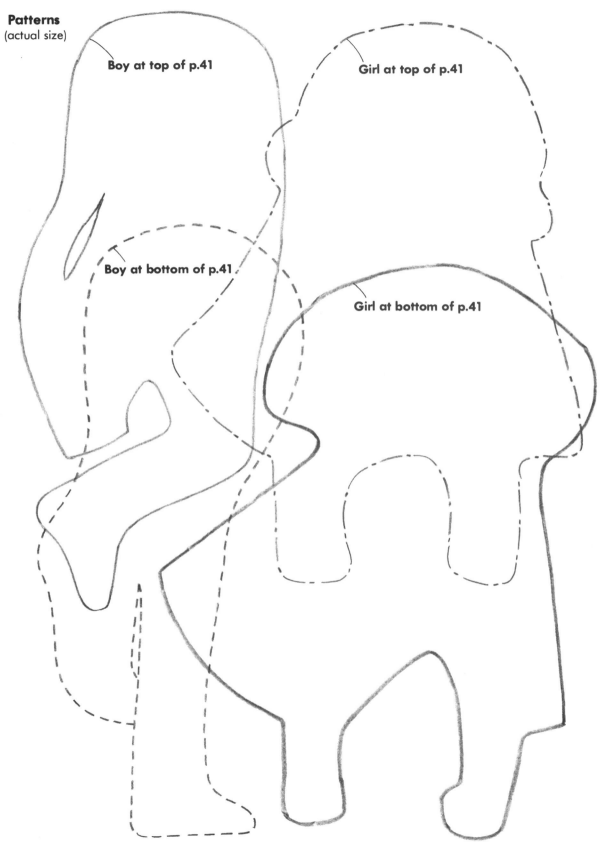

Patterns
(actual size)

Boy at top of p.41

Girl at top of p.41

Boy at bottom of p.41

Girl at bottom of p.41

97

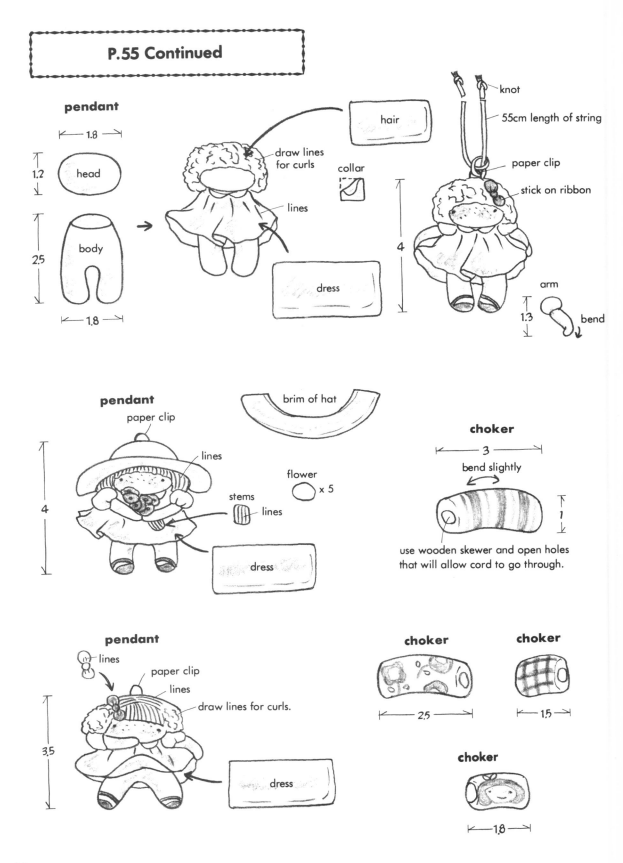

pendant

head
1.8
1.2

body
2.5
1.8

draw lines for curls

hair

collar

lines

dress

knot

55cm length of string

paper clip

stick on ribbon

4

arm
1.3
bend

pendant

paper clip

lines

brim of hat

flower ◯ x 5

stems
lines

lines

dress

4

choker

3

bend slightly

1

use wooden skewer and open holes that will allow cord to go through.

pendant

lines

paper clip

lines

draw lines for curls.

dress

3.5

choker

2.5

choker

1.5

choker

1.8

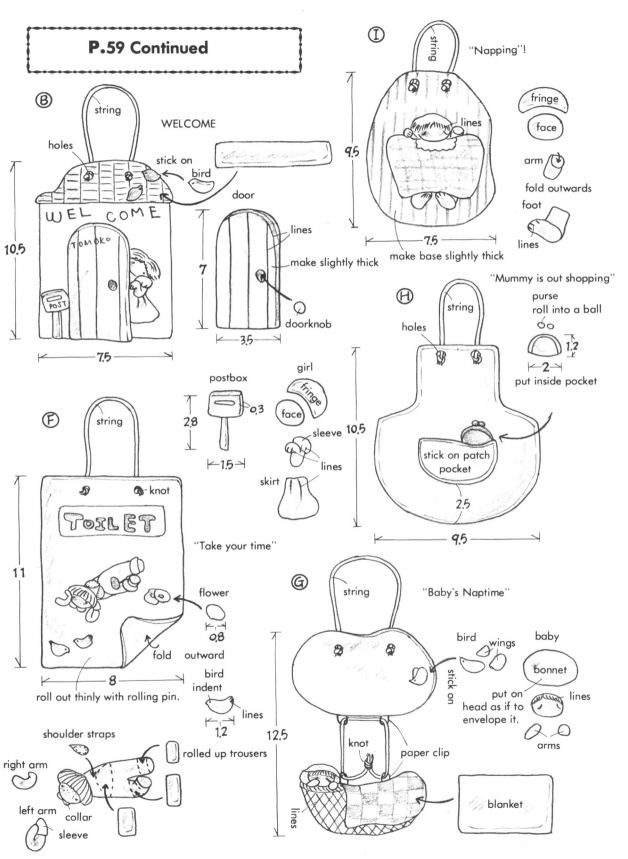

P.59 Continued

Ⓑ string

WELCOME

holes

stick on
bird

door

WEL COME

TOMOKO

POST

10.5

7.5

Ⓘ string

"Napping"!

lines

9.5

7.5

make base slightly thick

fringe

face

arm

fold outwards

foot

lines

door

lines

make slightly thick

doorknob

7

3.5

"Mummy is out shopping"

Ⓗ string

holes

purse
roll into a ball

1.2

2

put inside pocket

postbox

0.3

2.8

1.5

girl

fringe

face

sleeve

lines

skirt

10.5

stick on patch
pocket

2.5

9.5

Ⓕ string

TOILET

"Take your time"

11

flower

0.8

fold outward

bird
indent

lines

1.2

8

roll out thinly with rolling pin.

shoulder straps

right arm

left arm collar

sleeve

rolled up trousers

Ⓖ string

"Baby's Naptime"

bird

wings

baby

bonnet

stick on

lines

put on
head as if to
envelope it.

arms

knot

paper clip

12.5

lines

blanket

99

Doll Brooches p.61

You can make a doll that has a lot of movement by the way you arrange the legs and hands. The boy with his back to you will look more appealing if you put a little more clay onto his bottom.

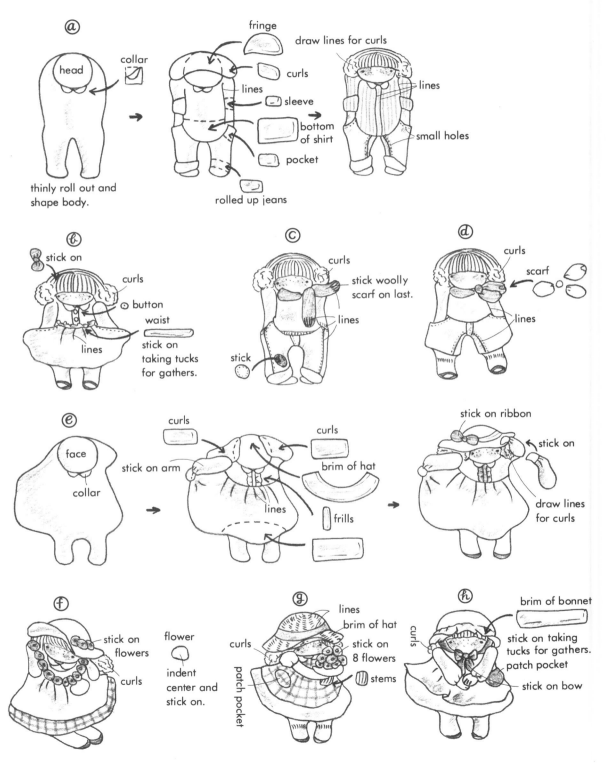

ⓐ collar

head

thinly roll out and shape body.

fringe

draw lines for curls

curls

lines

sleeve

bottom of shirt

pocket

rolled up jeans

lines

small holes

ⓑ stick on

curls

⊙ button

waist

stick on taking tucks for gathers.

lines

ⓒ curls

stick woolly scarf on last.

lines

stick

ⓓ curls

scarf

lines

ⓔ face

collar

stick on arm

curls

curls

brim of hat

lines

frills

stick on ribbon

stick on

draw lines for curls

ⓕ stick on flowers

curls

flower

indent center and stick on.

ⓖ lines

brim of hat

curls

stick on 8 flowers

stems

patch pocket

ⓗ curls

brim of bonnet

stick on taking tucks for gathers.

patch pocket

stick on bow

100

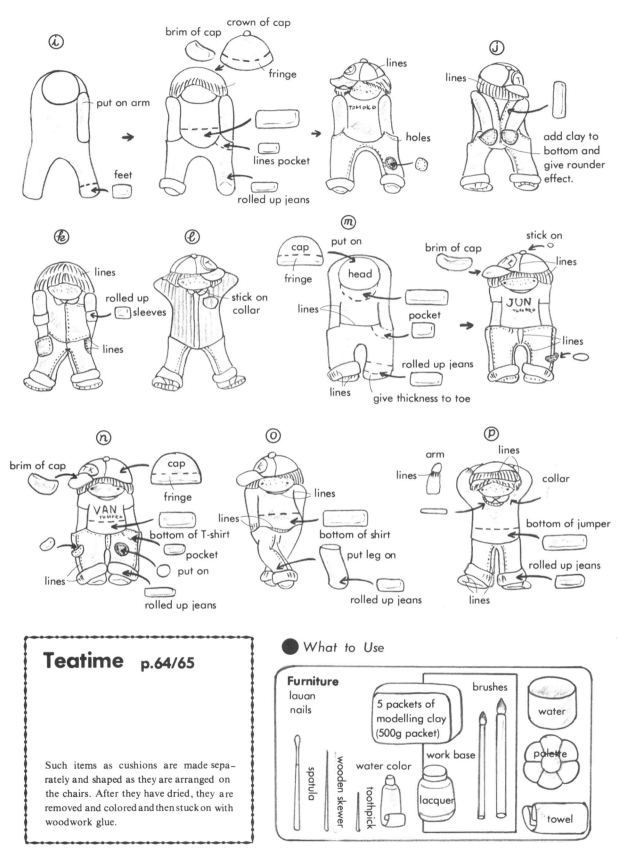

ⓘ

put on arm

feet

crown of cap
brim of cap
fringe

lines pocket

rolled up jeans

lines

TOMOKO

holes

ⓙ

lines

lines

add clay to bottom and give rounder effect.

ⓚ

lines

rolled up sleeves

lines

ⓛ

stick on collar

ⓜ

cap

fringe

put on

head

lines

pocket

rolled up jeans

lines

give thickness to toe

brim of cap

stick on

lines

JUN
TOMOKO

lines

ⓝ

brim of cap

cap

fringe

VAN
TOMOKO

bottom of T-shirt

pocket

put on

lines

rolled up jeans

ⓞ

lines

lines

bottom of shirt

put leg on

rolled up jeans

ⓟ

arm

lines

lines

collar

bottom of jumper

rolled up jeans

lines

Teatime p.64/65

Such items as cushions are made separately and shaped as they are arranged on the chairs. After they have dried, they are removed and colored and then stuck on with woodwork glue.

● What to Use

Furniture
lauan
nails

5 packets of modelling clay (500g packet)

brushes

water

work base

palette

spatula

wooden skewer

water color

toothpick

lacquer

towel

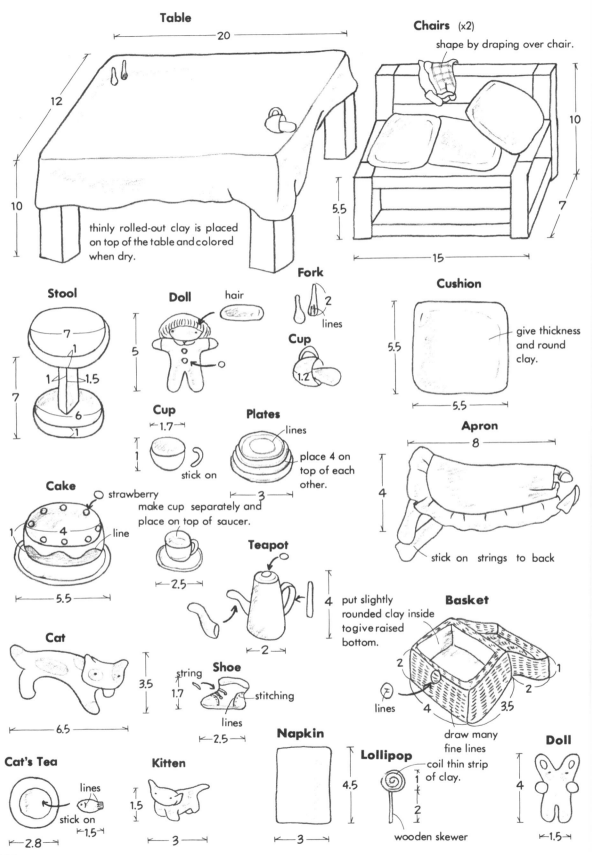

Table

20

12

10

thinly rolled-out clay is placed on top of the table and colored when dry.

Chairs (x2)

shape by draping over chair.

10

5.5

7

15

Stool

7

1

1 1.5

7

6

1

Doll

hair

5

Fork

2

lines

Cup

1.2

Cushion

5.5

give thickness and round clay.

5.5

Cup

1.7

1

stick on

Plates

lines

place 4 on top of each other.

3

make cup separately and place on top of saucer.

Apron

8

4

stick on strings to back

Cake

strawberry

1 4 line

5.5

2.5

Teapot

4

2

put slightly rounded clay inside to give raised bottom.

Basket

2 1

2

4 3.5

lines

draw many fine lines

Cat

3.5

6.5

Shoe

string

1.7

stitching

lines

2.5

Napkin

4.5

3

Doll

4

1.5

Cat's Tea

lines

stick on

2.8 1.5

Kitten

1.5

3

Lollipop

coil thin strip of clay.

1

2

wooden skewer

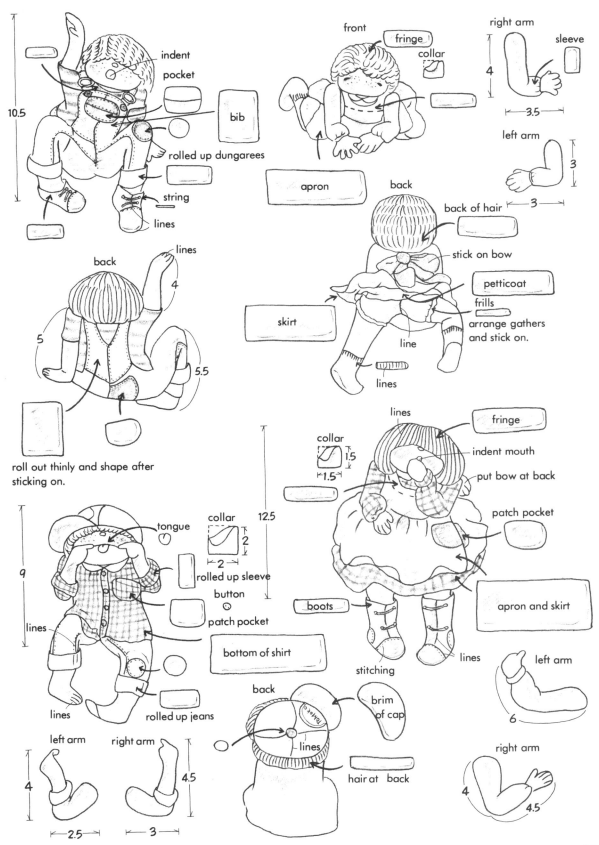

indent

pocket

bib

rolled up dungarees

string

lines

10.5

front

fringe

collar

right arm

sleeve

4

3.5

left arm

3

3

apron

back

back of hair

stick on bow

petticoat

frills

arrange gathers
and stick on.

skirt

line

lines

back

lines

4

5

5.5

roll out thinly and shape after
sticking on.

lines

fringe

collar

1.5

1.5

indent mouth

put bow at back

patch pocket

12.5

boots

apron and skirt

lines

stitching

tongue

collar

2

2

rolled up sleeve

button

patch pocket

bottom of shirt

9

lines

lines

rolled up jeans

back

brim
of cap

lines

hair at back

left arm

6

left arm

right arm

4

4.5

2.5

3

right arm

4

4.5

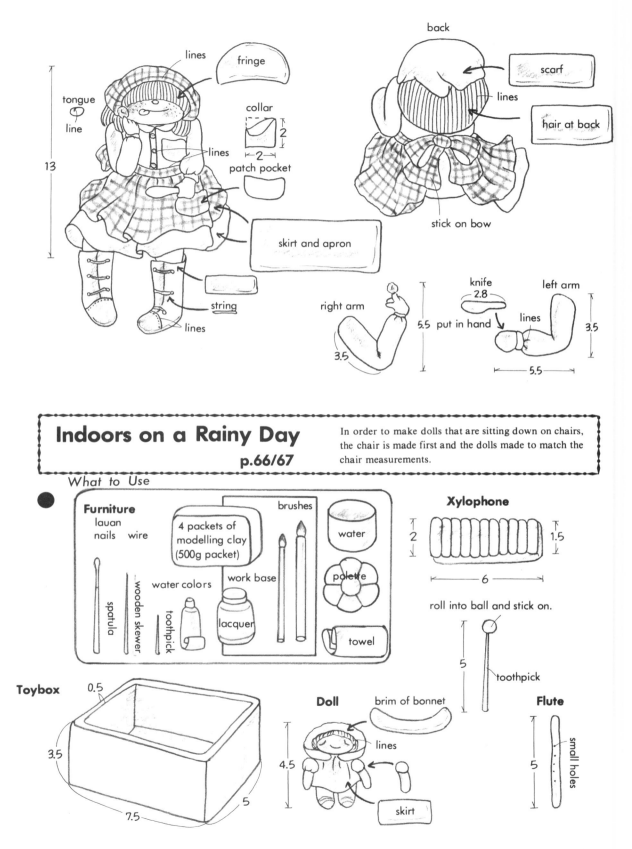

lines

fringe

tongue

line

collar

2

2

patch pocket

lines

13

lines

skirt and apron

string

lines

back

scarf

lines

hair at back

stick on bow

right arm

3.5

knife

2.8

put in hand

5.5

lines

left arm

3.5

5.5

Indoors on a Rainy Day
p.66/67

In order to make dolls that are sitting down on chairs, the chair is made first and the dolls made to match the chair measurements.

What to Use

Furniture

lauan

nails wire

spatula

wooden skewer

water colors

toothpick

4 packets of modelling clay (500g packet)

work base

lacquer

brushes

water

palette

towel

Xylophone

2

1.5

6

roll into ball and stick on.

5

toothpick

Toybox

0.5

3.5

7.5

5

Doll

brim of bonnet

lines

4.5

skirt

Flute

5

small holes

104

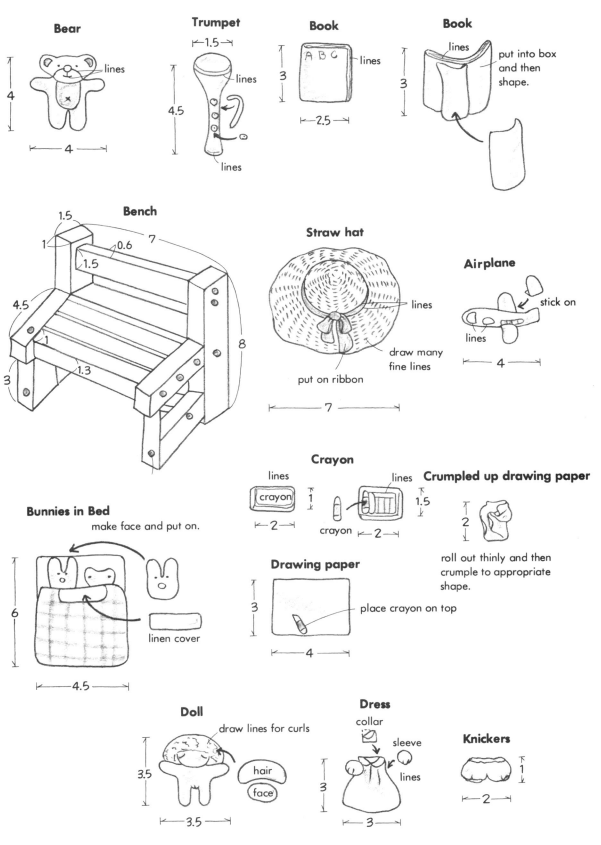

Bear

4
4
lines

Trumpet

1.5
4.5
lines
lines

Book

3
A B C
lines
2.5

Book

lines
put into box
and then
shape.
3

Bench

1.5
1
0.6
7
1.5
4.5
1
8
3
1.3

Straw hat

lines
draw many
fine lines
put on ribbon
7

Airplane

stick on
lines
4

Crayon

lines
crayon
2
1
lines
crayon
2
1.5

Crumpled up drawing paper

2

roll out thinly and then
crumple to appropriate
shape.

Bunnies in Bed

make face and put on.

6
linen cover
4.5

Drawing paper

3
place crayon on top
4

Doll

draw lines for curls
3.5
hair
face
3.5

Dress

collar
sleeve
lines
3
3

Knickers

1
2

105

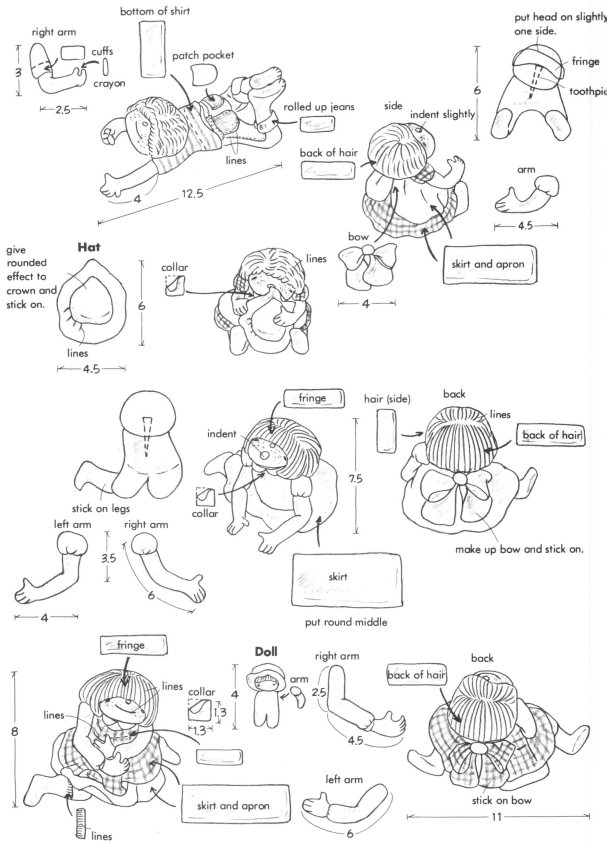

right arm

cuffs

crayon

3

←2.5→

bottom of shirt

patch pocket

rolled up jeans

lines

lines

4

12.5

put head on slightly one side.

fringe

toothpic

6

side

indent slightly

back of hair

bow

arm

←4.5→

skirt and apron

give rounded effect to crown and stick on.

Hat

lines

←4.5→

6

collar

lines

←4→

fringe

hair (side)

back

lines

back of hair

indent

collar

7.5

stick on legs

left arm

right arm

3.5

6

←4→

skirt

put round middle

make up bow and stick on.

fringe

lines

collar

lines

8

lines

lines

skirt and apron

Doll

arm

4

right arm

2.5

4.5

collar

1.3

1.3

left arm

6

back

back of hair

stick on bow

←———11———→

106

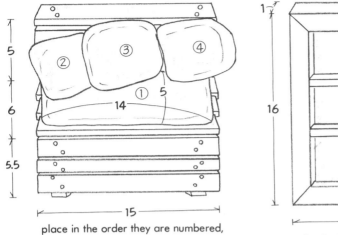

5
6
5.5

② ③ ④
① 5
14

15

place in the order they are numbered,
dry and color.

1
1.2
16
wire

14

make the frame and dampen surface
with water before puttng clay inside.

toothpick

3.5

3.5 — 5

front
fringe
lines

Cat

back front

4

back
back of hair

lines

bottom

make baggy

bottom of dungarees

left arm
2.8

right arm
line
3

front nose

fringe
indent

patch pocket
lines

button

left arm
3
4

right arm
3.5
4
lines

line stitching

side
lines
back of hair
sling
place inside
put on
string

rolled up
sleeve
7

patch pocket
13
rolled up dungarees

Nursery in the Clouds

p.68/69

In order to bring out the sweet charm of the babies, make them slightly fat. Do not finish it off with lacquer but allow the water colors to give off their natural softness.

What to Use

spatula

wooden skewer

1.5 packets of modelling clay (500g packet)

brushes

water

palette

toothpick

water colors

work base

towel

Basket

put on handles

2

lines

6

↓

Place a piece of clay rolled out to about 12cm x 12cm square inside the basket. Also put in a rounded piece of clay.

Gauze

(x 1)

2

loop

fold in two

1.5

Nappy (x 4)

3

loop

2.5

Baby's Clothing

collar

sleeve

stick on

2.5

5

loop

lines

bend backward

2.8

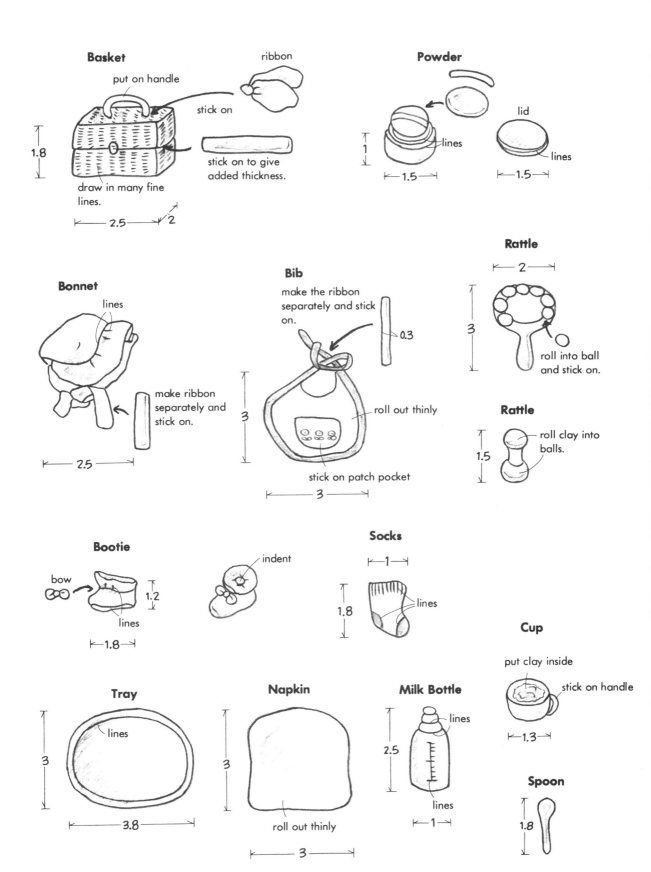

Basket

put on handle

ribbon

stick on

1.8

draw in many fine lines.

stick on to give added thickness.

2.5 ⟋2

Powder

lid

lines

1

1.5

lines

1.5

Rattle

2

3

roll into ball and stick on.

Bonnet

lines

make ribbon separately and stick on.

2.5

Bib

make the ribbon separately and stick on.

0.3

3

roll out thinly

stick on patch pocket

3

Rattle

1.5

roll clay into balls.

Bootie

bow

1.2

lines

1.8

indent

Socks

1

1.8

lines

Cup

put clay inside

stick on handle

1.3

Tray

lines

3

3.8

Napkin

3

roll out thinly

3

Milk Bottle

lines

2.5

lines

1

Spoon

1.8

109

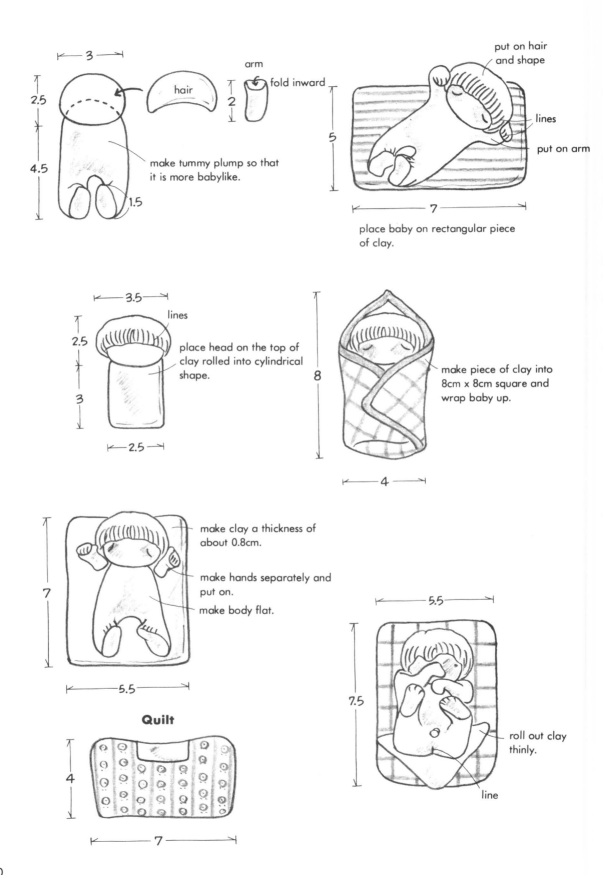

← 3 →

2.5

hair

arm

2 fold inward

4.5

make tummy plump so that
it is more babylike.

1.5

put on hair
and shape

lines

put on arm

5

← 7 →

place baby on rectangular piece
of clay.

← 3.5 →

lines

2.5

place head on the top of
clay rolled into cylindrical
shape.

3

← 2.5 →

8

make piece of clay into
8cm x 8cm square and
wrap baby up.

← 4 →

make clay a thickness of
about 0.8cm.

7

make hands separately and
put on.

make body flat.

← 5.5 →

Quilt

4

← 7 →

← 5.5 →

7.5

roll out clay
thinly.

line

110

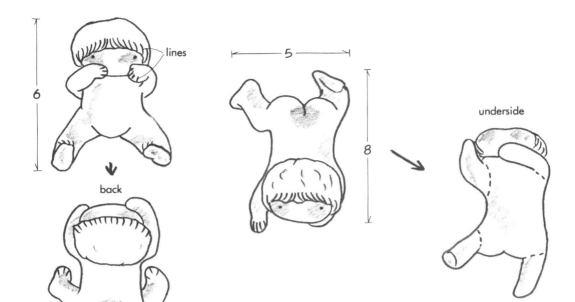

lines

back

underside

6

5

8





Framed Pictures p.70-73

Let's make some sweet, attractive framed pictures. You only need a little bit of wood. Once the frame is finshed, dampen the front surface to make it easier for the clay to stick.

How to Make a Frame
Wooden frame (Lauan is easy to handle)

14
1.4
1.2
11

1.4
16 13

1.2

16 back / veneer board

14

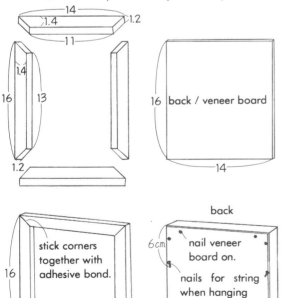

stick corners together with adhesive bond.

16

14

back

6cm nail veneer board on.

nails for string when hanging

What to Use

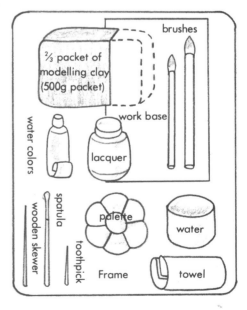

brushes

⅔ packet of modelling clay (500g packet)

work base

water colors

lacquer

wooden skewer

spatula

toothpick

palette

water

Frame

towel

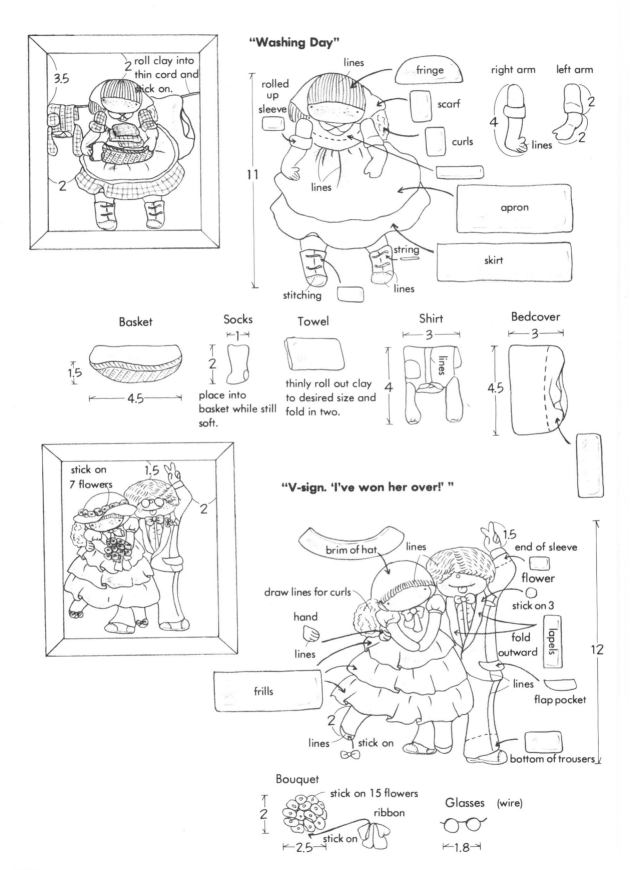

"Washing Day"

roll clay into thin cord and stick on.

3.5

2

lines

rolled up sleeve

fringe

scarf

curls

right arm left arm

4 2 2

lines

11

lines

apron

skirt

string

lines

stitching

Basket

1.5

4.5

Socks

1

2

place into basket while still soft.

Towel

thinly roll out clay to desired size and fold in two.

Shirt

3

4

lines

Bedcover

3

4.5

stick on 7 flowers

1.5

2

"V-sign. 'I've won her over!'"

brim of hat lines

1.5

end of sleeve

flower

stick on 3

draw lines for curls

hand

lines

fold outward

lapels

lines

flap pocket

frills

12

2

lines stick on

bottom of trousers

Bouquet

2

stick on 15 flowers

ribbon

stick on

2.5

Glasses (wire)

1.8

112

"Playing on Concert Day"

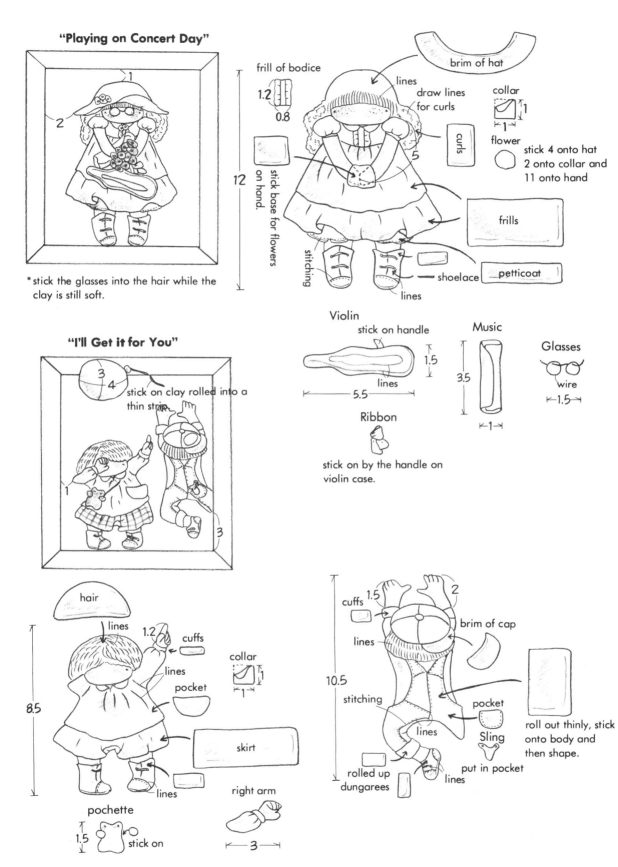

frill of bodice

1.2

0.8

* stick the glasses into the hair while the clay is still soft.

"I'll Get it for You"

stick on clay rolled into a thin strip.

lines

draw lines for curls

brim of hat

collar

1

1

curls

flower

stick 4 onto hat
2 onto collar and
11 onto hand

5

12

stick base for flowers on hand.

stitching

shoelace

lines

frills

petticoat

Violin

stick on handle

lines

5.5

1.5

Ribbon

stick on by the handle on violin case.

Music

3.5

1

Glasses

wire

1.5

hair

lines

1.2

cuffs

lines

pocket

collar

1

1

8.5

skirt

lines

right arm

pochette

1.5

stick on

3

cuffs

1.5

lines

brim of cap

2

stitching

lines

pocket

Sling

put in pocket

roll out thinly, stick onto body and then shape.

10.5

rolled up dungarees

lines

"I Went on an Errand and I Got a Balloon"

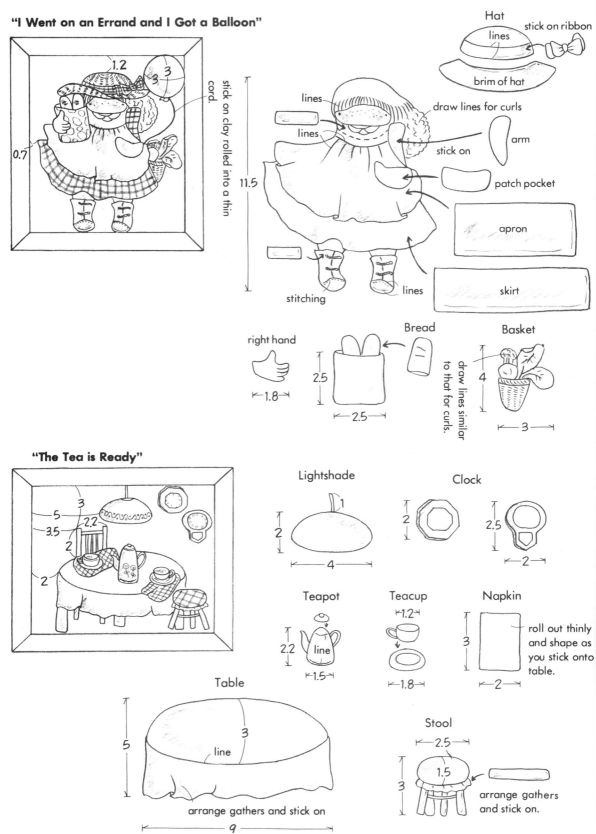

1.2

3 3

0.7

11.5

stick on clay rolled into a thin cord.

Hat

lines

stick on ribbon

brim of hat

lines

lines

draw lines for curls

stick on

arm

patch pocket

apron

skirt

stitching

lines

right hand

⊢1.8⊣

Bread

2.5

⊢2.5⊣

draw lines similar to that for curls.

Basket

4

⊢3⊣

"The Tea is Ready"

3
5
3.5
2.2
2
2

Lightshade

2

⊢4⊣

1

Clock

2

2.5

⊢2⊣

Teapot

2.2

line

⊢1.5⊣

Teacup

⊢1.2⊣

⊢1.8⊣

Napkin

3

⊢2⊣

roll out thinly and shape as you stick onto table.

Table

5

3

line

arrange gathers and stick on

⊢———9———⊣

Stool

⊢2.5⊣

1.5

3

arrange gathers and stick on.

114

"I Wonder Who's Coming..."

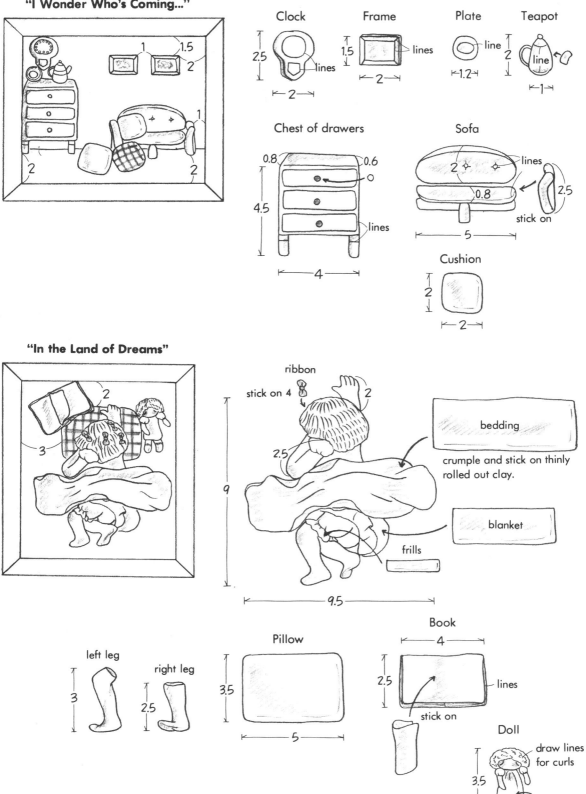

Clock
2.5
lines
2

Frame
1.5
lines
2

Plate
line
1.2

Teapot
2
line
1

Chest of drawers
0.8 0.6
4.5
lines
4

Sofa
lines
2
0.8
2.5
stick on
5

Cushion
2
2

"In the Land of Dreams"

ribbon
stick on 4
2
2.5
9
9.5

bedding
crumple and stick on thinly
rolled out clay.

blanket

frills

left leg
3

right leg
2.5

Pillow
3.5
5

Book
4
2.5
lines
stick on

Doll
draw lines
for curls
3.5
bottom of dress

"My Room"

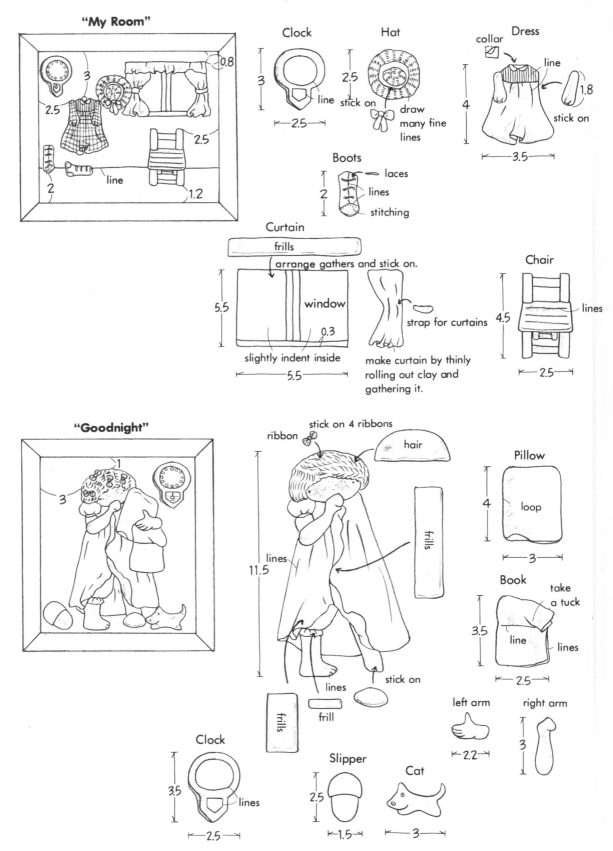

Clock
3
line
2.5

Hat
2.5
stick on
draw many fine lines

Dress
collar
line
4
1.8
stick on
3.5

Boots
laces
lines
stitching
2

Curtain
frills
arrange gathers and stick on.
5.5
window
0.3
slightly indent inside
5.5
strap for curtains
make curtain by thinly rolling out clay and gathering it.

Chair
lines
4.5
2.5

"Goodnight"
1
3
11.5

stick on 4 ribbons
ribbon
hair
lines
frills
stick on

Pillow
4
loop
3

Book
take a tuck
3.5
line
lines
2.5

frills
frill
lines

left arm
2.2

right arm
3

Clock
3.5
lines
2.5

Slipper
2.5
1.5

Cat
3

116